D0805627

FEDERICO ZERI (Rome, 1921-1998), eminent art historian and critic, was vice-president of the National Council for Cultural and Environmental Treasures from 1993. Member of the Académie des Beaux-Arts in Paris, he was decorated with the Legion of Honor by the French government. Author of numerous artistic and literary publications; among the most well-known: *Pittura e controriforma*, the Catalogue of Italian Painters in the Metropolitan Museum of New York and the Walters Gallery of Baltimora, and the book *Confesso che ho sbagliato*.

Work edited by FEDERICO ZERI

Text
based on the interviews between
FEDERICO ZERI and MARCO DOLCETTA

This edition is published for North America in 2000 by NDE Publishing*

Chief Editor of 2000 English Language Edition
ELENA MAZOUR (*NDE Publishing**)

English Translation
SUSAN SCOTT

Realization
ULTREYA, MILAN

Editing
LAURA CHIARA COLOMBO, ULTREYA, MILAN

Desktop Publishing
ELISA GHIOTTO

ISBN 1-55321-026-3

Illustration references

Alinari Archives: 12b, 45/III.

Bridgemann/Alinari Archives: 12a, 15, 25, 29, 33, 34, 37d, 43, 44/I-VI, 45/XIII.

Giraudon/Alinari Archives: 4b, 10b, 11, 28b, 30s-d, 35, 37as-bs, 38as, 42b, 43b, 45/IX-XIV, 47, 48.

Luisa Ricciarini Agency: 4c, 7c-b, 16b, 21, 36b, 38b, 39, 41b, 42a.

RCS Libri Archives: 1, 2-3, 4a, 5, 6-7, 7a, 8a, 9, 10a, 16a, 17, 18, 20, 22, 24a-c-b, 26-27, 28a, 31, 32s, 36a, 38ad, 44/VIII-IX, 45/II-IV-V-VI-VIII-XII.

R.D.: 2, 8b, 13, 14, 19, 23, 32ad-bd, 40a, 41a, 44/II-III-IV-V-VII-X-XI-XII, 45/I-VII-X-XI.

Printed and bound by Poligrafici Calderara S.p.A., Bologna, Italy

* a registered business style of NDE Canada Corp.
15-30 Wertheim Court, Richmond Hill, Ontario
L4B 1B9 Canada, tel. (905) 731-1288

The captions of the paintings contained in this volume include, beyond just the title of the work, the dating and location. In the cases where this data is missing, we are dealing with works of uncertain dating, or whose current whereabouts are not known. The titles of the works of the artist to whom this volume is dedicated are in blue and those of other artists are in red.

MODIGLIANI
RECLINING NUDE

A turbulent, tragic life has made of Modigliani a cult figure and a symbol of twentieth century art. An accomplished painter, superb draftsman, and extraordinary sculptor, whether with stone or canvas, he transforms faces to bring out their spiritualized

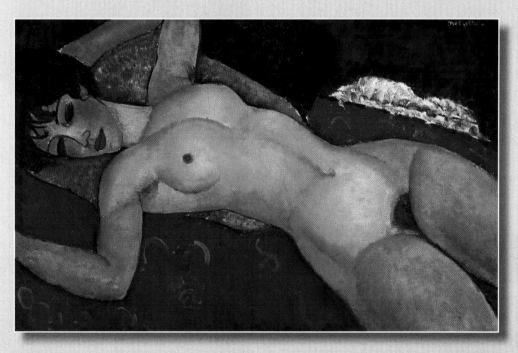

features, paints eyes without pupils, elongates necks to the point of deformation, and with his elegant profiles gives an interpretation of Cubism revisited in the light of classical art.

Federico Zeri

A MODERN CLASSIC

RECLINING NUDE
1917

● Milan, private collection (oil on canvas, 60x92 cm)

● From his birth in Livorno in 1884, Amedeo Modigliani suffered from weak lungs which made his brief life a series of alternating periods of illness and convalescence. Struck by typhus at the age of 14, Dedo, as his family called him, while ill expressed his aspiration to become a painter, but already by January 1920, in Paris, tuberculosis had put an end to his artistic career.

● Until 1906, when he moved to France, Modigliani absorbed the Italian cultural and artistic tradition. He fell in love with fourteenth century Sienese and Venetian Renaissance painting and mastered the sense of balance and elegant composure which would soon characterize his art.

● Despite friendships with Picasso, Brancusi, and others among those responsible for the birth of modern art, Modì remained an outsider to their aggressive debate on form, and preferred the mysterious charm of primitive and Egyptian sculpture; in effect, Modigliani is a modern classic. Right when his friends were subverting tradition, he revived its genres and painted portraits and nudes, among them that masterpiece of compositional synthesis and linear elegance which is the *Reclining Nude*.

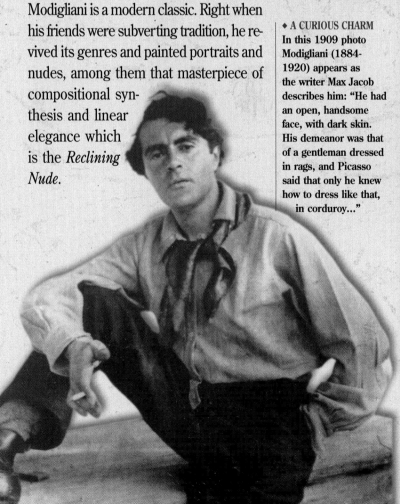

◆ **A CURIOUS CHARM**
In this 1909 photo Modigliani (1884-1920) appears as the writer Max Jacob describes him: "He had an open, handsome face, with dark skin. His demeanor was that of a gentleman dressed in rags, and Picasso said that only he knew how to dress like that, in corduroy…"

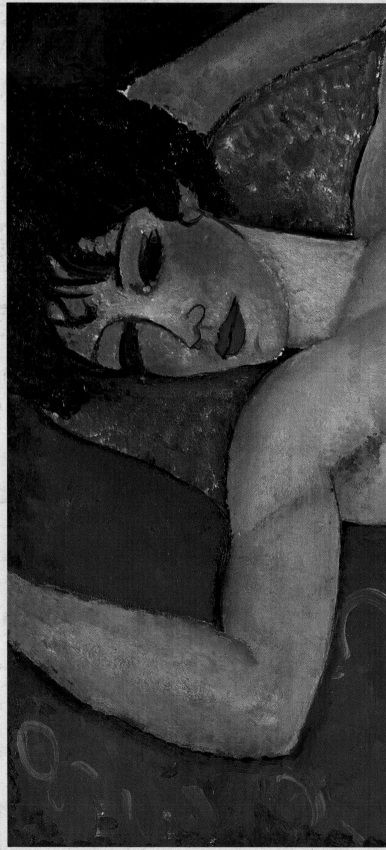

♦ A MAN AND HIS LEGEND

Amedeo Modigliani was born in Livorno on July 12, 1884 and died in Paris January 24, 1920. The son of middle-class Jewish merchants, cultivated and curious, Amedeo had a restless temperament which made his friends sometimes call him an aristocratic seducer, and other times a vulgar, arrogant drunk. Although his fragile health demanded that he lead a regular, controlled life, in Paris, where his personality gave rise to the legend of a Bohemian artist, he smoked hashish, drank to excess, and falling into poverty, suffered from hunger. Nonetheless, it was out of just these straitened circumstances that his art was born and flourished; the *Reclining Nude* is one of its most suggestive examples.

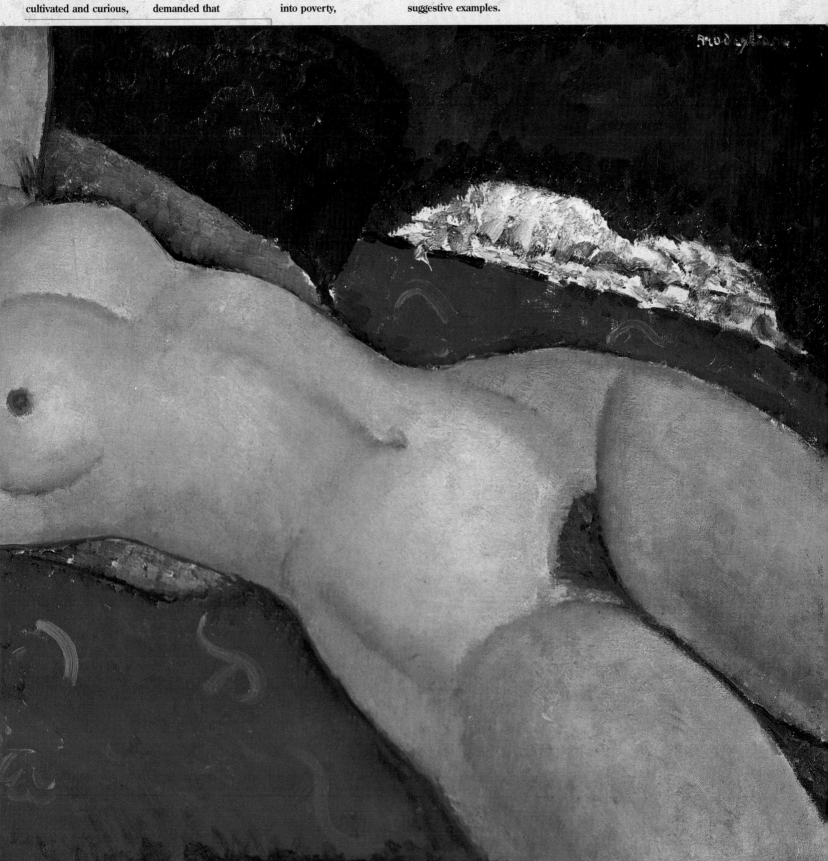

AN ELEGANT SIMPLIFICATION

This canvas is the apex of a substantial series of nudes painted by Modigliani in 1917, in which he depicted a nameless model with minimal variations in the poses. Here he places her on a diagonal and, using a very close viewpoint, lets her silhouette fill the space completely.

● The woman's pose is completely unself-conscious, offering herself to the observer's eye with no attempt to hide her body. The plasticity of the figure is rendered by the soft shadows of her body, but even more by the bold cutting off of the legs which, bent at an angle, extend beyond the edge of the canvas.

● With respect to the traditional description of nudes, coyly surrounded by allusive attributes, Modigliani effects a simplification of both the composition and the figure, deprived of any narrative reference. The artist ignores placement in space to concentrate on the human form, which is made even more imposing and provocative by the foreshortening of the legs.

● The painter does not aim here at a photographic reproduction of the model, but in a strongly contrived manner eliminates the natural aspects of the image to accentuate its artificial, timeless value. This formal concern, manifested especially in the elongated shape of the neck and the almost geometrical stylization of the body and face, indicates a search for absolute harmony and beauty.

● To the erotic message traditionally underlying female nudes, Modigliani responds with a cold, contained image, devoid of any vitality and practically sculptural, which strikes the observer with its gelid elegance. A melancholy note is inserted into this mysterious sensuality by the dark eyes, depicted as deep almond-shaped slits, suggesting both sleep and a provocative invitation. This unusual voluptuousness is reinforced by the essential nature of the composition, where the viewer's gaze finds nothing extraneous to distract his attention.

◆ AFRICAN YARUBA MASK (n.d., Geneva, private collection). Modigliani took his geometric eye sockets from primitive sculptures.

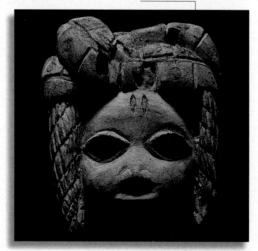

◆ FRANCISCO GOYA *Maya Desnuda* (1800, Madrid, Prado). Modigliani borrows from Goya the model's pose, but attenuates the seductiveness of her glance.

◆ AN AMBIGUOUS GAZE

Following the pose traditionally adopted, from the Venetians Titian (1488/90-1576) to Giorgione (c. 1477-1510) to the Spaniard Francisco Goya (1746-1828), Modigliani places his model on her back, leaning slightly forward with her arms above her head, her breasts lifted to suggest to the viewer her complete availability. But instead of the seductive, complicitous gaze one might expect, here the dark eyes are empty, impenetrable, suspended between invitation to and lack of interest in the observer, inspired by African masks, whose allure had recently been propounded by Picasso.

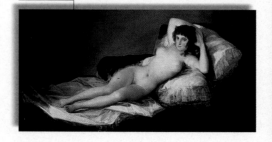

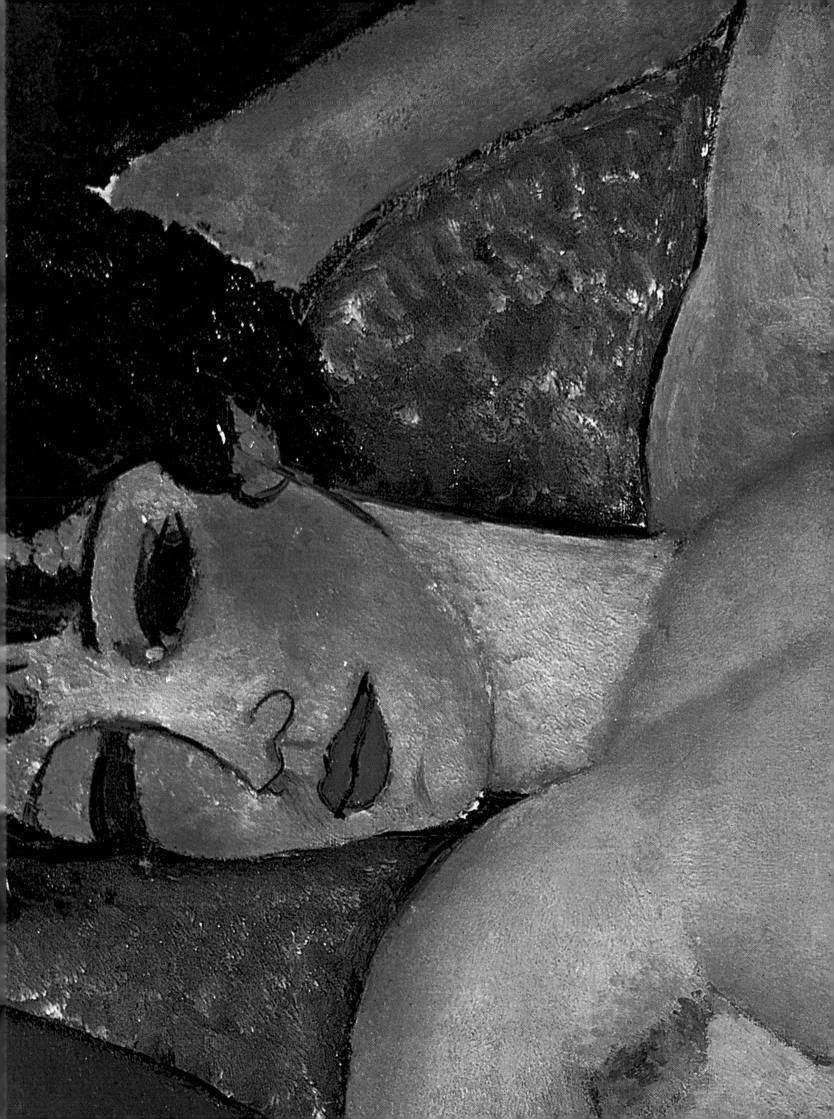

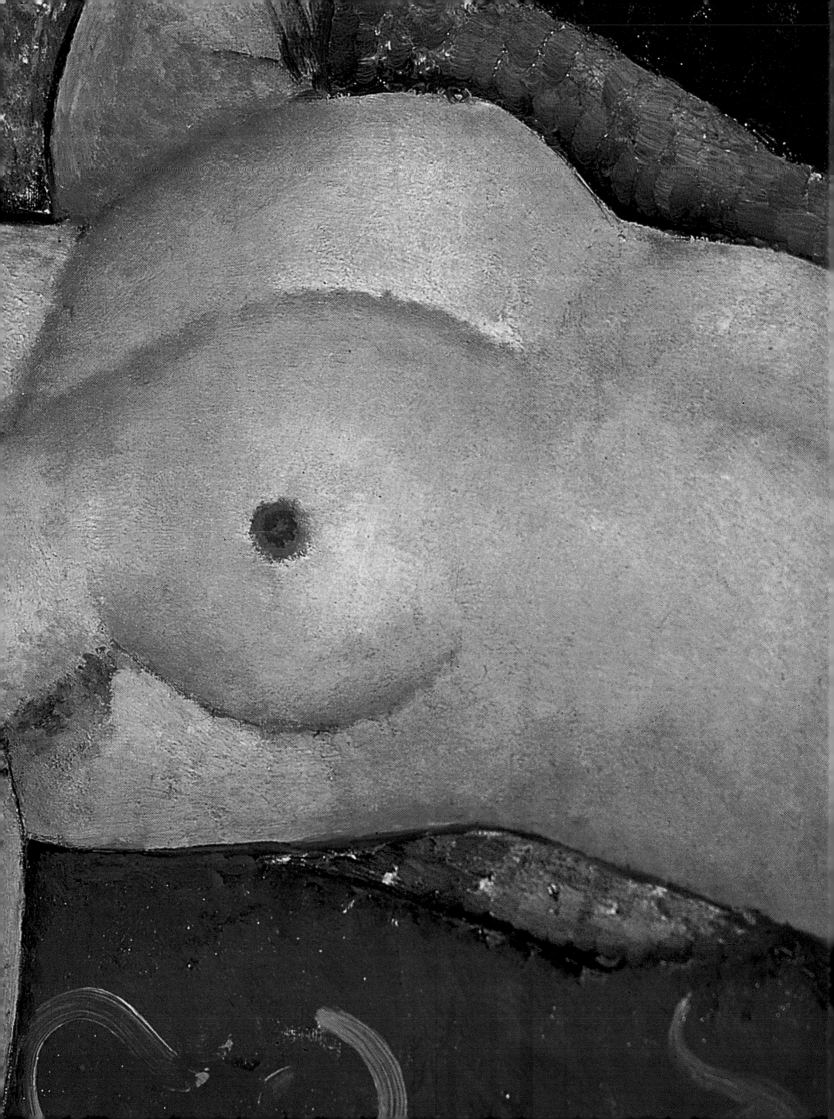

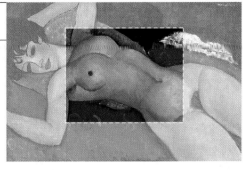

♦ SOFT MODELING
Modigliani skillfully
suggests all
the softness of
the young woman's
skin, highlighting
its warm color.
With a light contour
line that summarizes
the forms and delicate
tonal passages,
the painter describes
the carnality of her
body, heightened by
the contrast with the
cool blue of the pillow.

A disquieting note is
her underarm hair,
an unexpected
intrusion of realism
into an otherwise
artificial representation
of the nude. It was just
this detail which
aroused such an outcry
at the 1917 exhibition
in the Weill gallery,
from which some
pictures were removed:
academic polish does
not provide for such
realistic details.

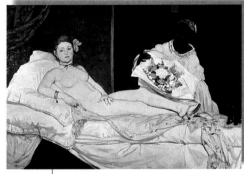

♦ EDOUARD MANET
Olympia
(1863, Paris,
Musée d'Orsay).
The academic pose
adopted by the French
painter scandalized
the public because
it was set in
contemporary reality,
just as Modigliani's
nude had caused
a sensation with its
realistic details inserted
into a traditional image.

♦ TITIAN
The Venus of Urbino
(c. 1538,
Florence, Uffizi).
The elegance of
the goddess's pose, in
the painting created
as a wedding gift
as an invocation of
fecundity, is accentuated
by the detail of
the flowers and bears
a narrative content
foreign to Modigliani's
expressive synthesis.

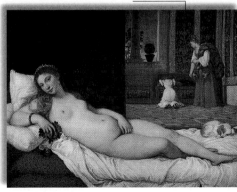

A WARM TONALISM

Modigliani usually painted with a palette containing subdued, almost monochromatic tones, which appear impenetrable to any light but impart warmth to the scene. In his works, no light source ever works to construct the image; color itself, in its various modulations, molds the forms. With a masterful balance of tonal passages, his brushstrokes are both rapid and deliberate at the same time, suspended between the undefined background and the carefully studied foreground.

● In the spare composition of *Reclining Nude*, only the variations in color allow us to distinguish the few elements creating the setting: the pillow, the sheets, the red sofa. Especially the pillow, with its traditional allusions to lust, functions to communicate the image's sense of languor and softness; further, through the chromatic contrast between its blue tones and the rosy flesh of the young woman, it brings her body forward and gives it physical presence.

● Modigliani works with a pasty, soft pigment, enlivened by strong reddish highlights in the flesh tones, to the point that this canvas has also been called *Red Nude*. The red tones work to pull the composition together, as they move from the arabesques on the day-bed and the intense coloring of the body to the model's cheeks and lips.

● This canvas was shown in December 1917 in the personal exhibition organized for Modigliani at Berthe Weill's gallery with the mediation of Leopold Zborowski, and is one of the nudes which caused the greatest sensation. The provocativeness of the body, accentuated by the absence of any allegorical or mythological justification, is heightened by the realism with which, in a generally simplified context, the artist depicts her underarm and pubic hair and the roundness of her hips and breasts.

● Nonetheless, it is evident how Modigliani remains faithful to classical culture and, without once lapsing into vulgarity, manages to maintain intact the sober elegance of the canvas. No out-of-place realistic detail interrupts the undulating rhythm of the lines or the masterful harmony of the colors, while the discreet steady, evenly spread luminosity, which exalts the sensuality of the scene, seems to hint a clandestine idea of the painter's intimacy with the model, an intimacy about which anecdotes have proliferated and contributed to the artist's legend.

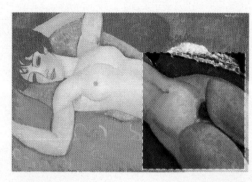

◆ RECLINING NUDE WITH LEFT ARM OVER HER FOREHEAD (1917, New York, Richard S. Zeiler collection). The canvas was painted in the same year as the *Reclining Nude with Lifted Arms*, of which it repeats the composition of the figure stretched out on a red day-bed with arabesques and a blue pillow, as well as the diagonal pose, with the legs tracing an angle of foreshortening which extends beyond the picture plane. Compared to the more famous Milanese canvas, this one lacks its arcane, mysterious charm due to the greater realism of the face: the open eyes looking out at the viewer repeat the scheme of academic nudes, whose gaze holds a seductive invitation.

◆ A CURIOUS SENSE OF SPACE The composition concentrates on the female figure and barely suggests the background with short dark brushstrokes, which only at a distance are visible as a pillow. For the rest, these shapeless splotches appear ambiguous and flat, in contrast to the plasticity of the body. The three-dimensionality of the scene is created mainly by tonal passages, except for the brilliant spatial solution adopted for the legs that, tracing an angle toward the foremost plane, introduce a dynamic element into the composition and dilate the space. By placing the pubic area so boldly in the foreground, Modigliani echoes Courbet and provokes the viewer.

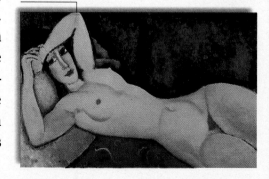

A BOHEMIAN LIFE

Young and charming, ill but stubbornly dissolute, poor but cultivated, above all a genius and a transgressor: this is the portrait of Modigliani which has fed the legend of Bohemian artist. This legend, increased by the scarcity of reliable documents about his life, conditioned reception of his work from the beginning. An extraordinary painter and sculptor, yet he owed his early fame to his life as a man devoured by alcohol and illness, unbearable but loved by women to an extreme, as is revealed by Jeanne Hébuterne's suicide the day after his death, while she was expecting their second child. The legend incorporates novelistic clichés to excess, but this did not intimidate directors like the French Jacques Becker or Franco Brogi Taviani,

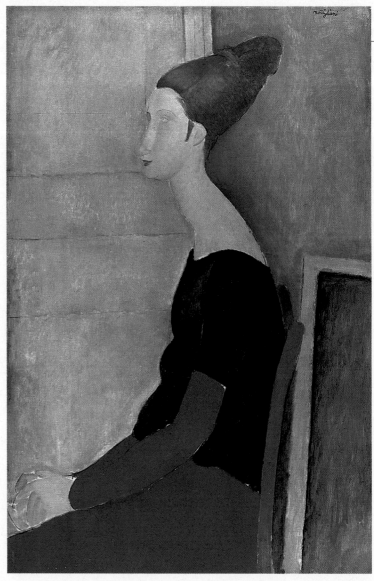

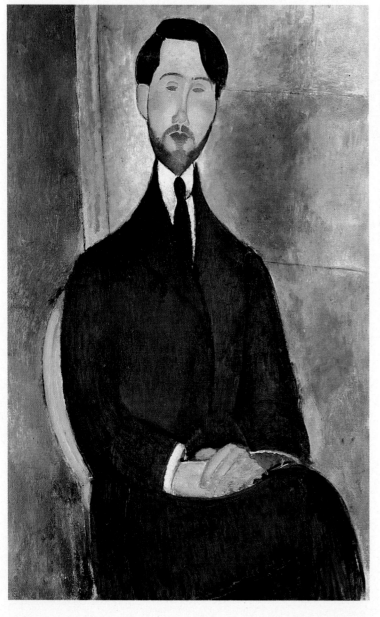

whose films emphasize the contrast between the abandon of his life and the strict, measured control of his art.

● Brought up in a cultivated family (apparently his mother was a descendant of the philosopher Spinoza), Modigliani developed a passion for literature; his friends remember how he would recite from memory Dante, Wilde, Baudelaire, and always had in his pocket *Les Chants de Maldoror* by Lautreamont.

● Modigliani advocated humanitarian socialism and poured this sense of solidarity with the most humble into his portraits of poor people, whose dignity he acknowledges even in their poverty. Taking an antibourgeois position, he felt it was his task to show up hypocrisy and human pain, but without passing judgment.

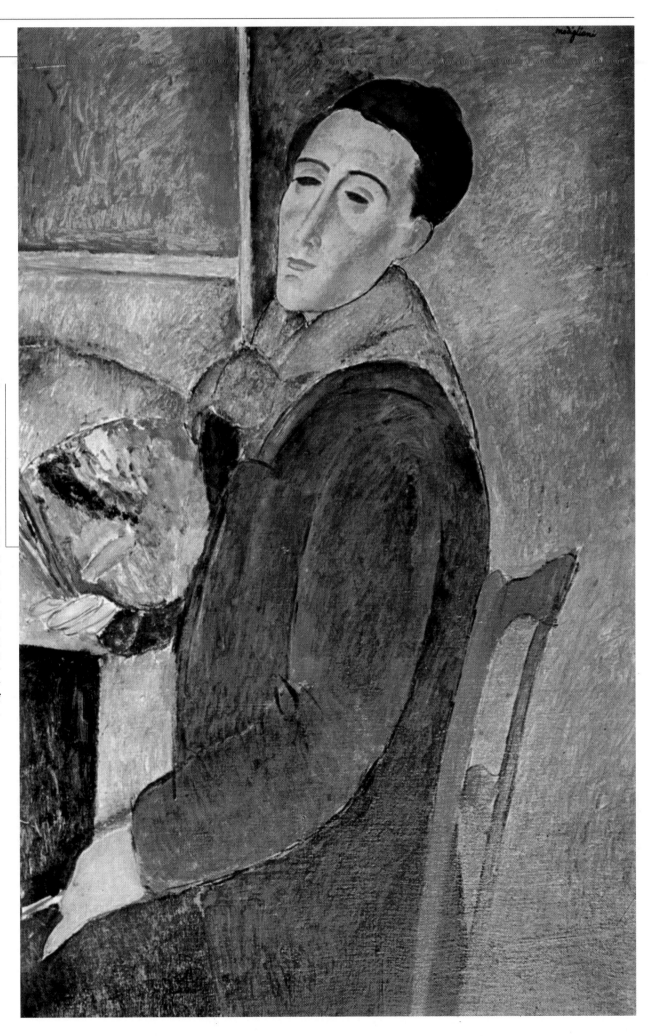

◆ JEANNE HEBUTERNE
SEATED, IN PROFILE,
IN A RED DRESS
Jeanne Hébuterne
met Modigliani
in 1917 and
immediately became
his faithful companion
and the mother of his
daughter, the only
child recognized
by Modigliani.
The artist made
numerous paintings
of her like this one,
in which
he Manneristically
elongates her swan-like
neck, oval face,
and light eyes.

◆ SELF-PORTRAIT
(1919, São Paulo,
Museu de Arte).
This is Modigliani's
only self-portrait,
painted a few months
before his death, as is
evidenced by his
emaciated face,
hollowed out by illness.
As in a sort of artistic
testament, the artist
depicts himself palette
in hand, his eyes
half-closed and
inexpressive like in
the many faces he
painted. While the
brushstroke is rapid
and sometimes
imprecise, the sober
tones he uses show
a skillful balance of
warm and cool colors.

◆ LEOPOLD ZBOROWSKI
SITTING DOWN
(1919, São Paulo,
Museu de Arte).
The elegant plastic
line outlines
the silhouette
of the Polish poet,
in a compact form
closed to outside
contact. Zborowski
was an art dealer
and one of the closest
friends and most
constant supporters
of Modigliani, even if
at the artist's death
he became the target
of criticism.

FROM LIVORNO TO PARIS

Modigliani's first painting experiences took place in Livorno, where he attended courses at the Accademia d'Arte taught by Guglielmo Micheli (1886-1926), a former student of the Macchiaiolo painter Giovanni Fattori (1825-1908). A product of this period is one of his rare landscapes, whose solitary atmosphere prefigures the melancholy tone typical of his best-known works.

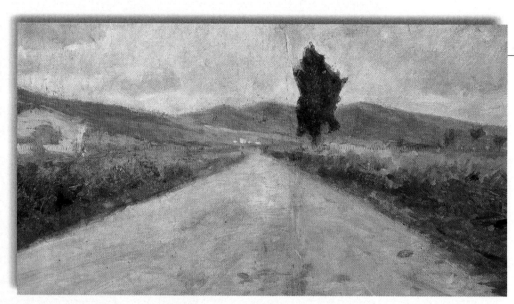

● Before moving to Paris, Modigliani concentrated on the study of Italian art, but transferred little of what he learned onto canvas. First with his mother and then with his friend Oscar Ghiglia, he made a series of trips to explore the Florentine, Roman, and Venetian artistic traditions.

● Fleeing the provincialism of Livorno, in Florence he enrolled in the Scuola Libera di Nudo, and was enthralled by the art of Botticelli and fourteenth century painting, with its ethereal, intensely spiritual figures. In Venice, where he followed Ghiglia and enrolled in another course in the nude, he was conquered by Carpaccio's narrative style. Here, at the 1905 Biennale, he came into contact with Impressionist painting, the bold sculpture of Auguste Rodin (1840-1917), and the decorativism of Klimt. Thus he began to finalize a decision to move to Paris, where he arrived in the winter of 1906. With his nonconformist spirit, Modigliani broke with the provincial serenity of Livorno to settle in the capital of France, which he saw as a creative forge marked by freedom of expression; here he put aside his bourgeois clothes to don those of the rebellious artist, isolated in his own absolute convictions.

● Although various works are documented from his years in Italy, in reality Modigliani's first pictures which have survived to our day were painted in Paris. These are almost visionary works, pervaded by dark, tar-like colors, where the often ghostly outlines of the figures stand out against monochrome grounds. A sort of northern symbolism dominates the canvases, while the handling of the paint is discontinuous, haphazard, based on strong color contrasts.

● In Paris Modigliani enrolled in the Colarossi Academy, where once again he took courses on the nude. He met Maurice Utrillo (1883-1955), who became one of his best friends, and slowly became part of the dazzling whirl of Montmartre, finding in Paul Alexandre his first patron. In 1907 he took part in the *Salon* show, and at a retrospective dedicated to Cézanne discovered his ideal model; following Cézanne's example, he lightened his palette and made his figures more sculptural. But his painting activity was destined to break off abruptly in 1909, overwhelmed by a more intense passion for sculpture, which would absorb him almost exclusively until 1914.

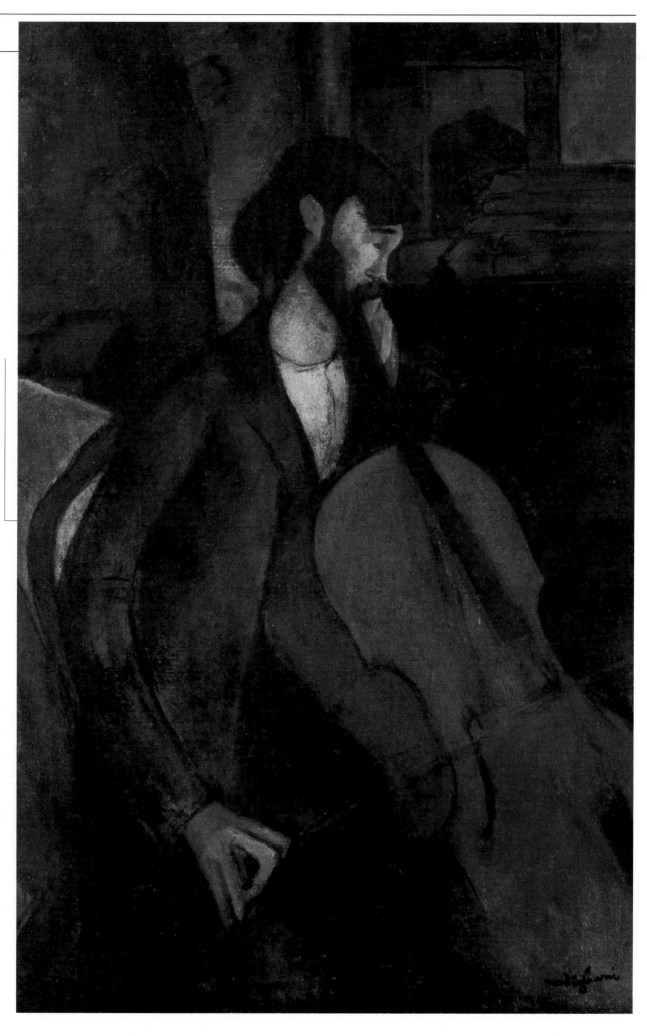

◆ TUSCAN LANDSCAPE
(1898, Livorno,
Museo Civico Fattori).
Just recently restored
to Modigliani's
catalogue, the painting
is the only surviving
witness of his early
painting in Livorno.
Painted in the same
somber vein as
Fattori's landscapes,
the work already
reveals Modigliani's
lack of interest
in the problems
of light and thus
in realistic painting.

◆ THE CELLO PAINTER
(1909, private
collection).
Using a compositional
structure that recalls
Cézanne, both in
the framing and
in the brushstroke
used to construct
the image, as well as
the dark tones,
Modigliani fills
the canvas with this
elongated figure:
the curious description
of the eyes, barely
hinted, makes the man
seem completely
wrapped in his music.
Through the plastic
facial features
Modigliani grasps
the intimate nature
of this male figure.

◆ GIOVANNI FATTORI
Maremma
(n.d., Rome, Galleria
d'Arte Moderna).
Modigliani met Fattori
when he was still
a child; a photo remains
of their meeting,
showing the smiling boy
with his arm around
the shoulders of
the older artist. Here
can be seen clearly
the evocative charge of
Fattori's pictures which
influenced Modigliani,
who borrowed his
absorbed, melancholy
atmosphere and
the sober tones
of his palette.

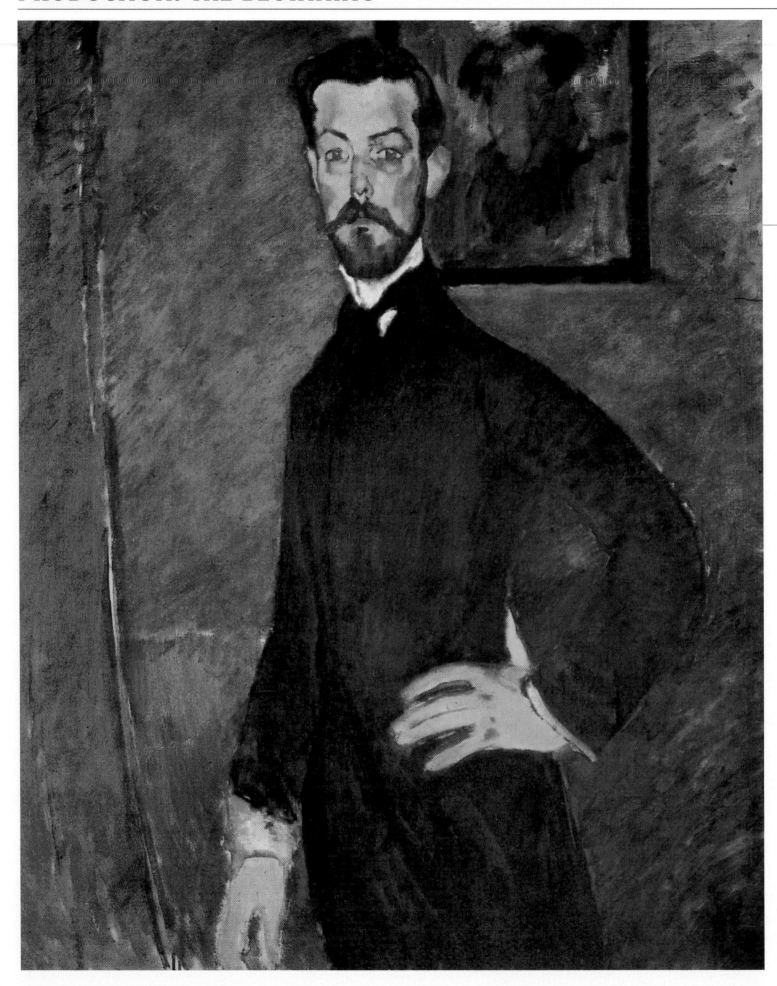

◆ PAUL ALEXANDRE ON
A GREEN BACKGROUND
(1909, private
collection).
Against a background
skillfully constructed
on the contrast
between two
complementary colors,
red and green, which
give light to the scene,
Modigliani portrayed
the young doctor Paul
Alexandre, an art lover
and future supporter
and patron of many
artists, including
Modigliani himself,
to whom he made
available a house
on the Rue du Delta,
on Montmartre.
The subject's pose is
austere and artificial,
while the patches
of color defining the
face recall Cézanne's
manner of modelling,
at the time
Modigliani's main
point of reference.

◆ THE RIDER
(1909, private collection).
This canvas was the first
official commission
Modigliani received,
thanks to
the mediation of his
friend Paul Alexandre.
The woman dressed for
riding is Baroness
Marguerite de Hasse de
Villers, who posed
wearing an elegant red
jacket; seeing herself
depicted in a yellow
jacket, which
the painter had changed
purely for aesthetic
reasons, she took
Modigliani's arbitrary
decision as a personal
affront and refused
to pay for the painting,
which was bought
by Paul Alexandre.
With her proud,
determined pose, shown
in three-quarters profile
against a green
background, the Baroness
seems to challenge
the viewer.

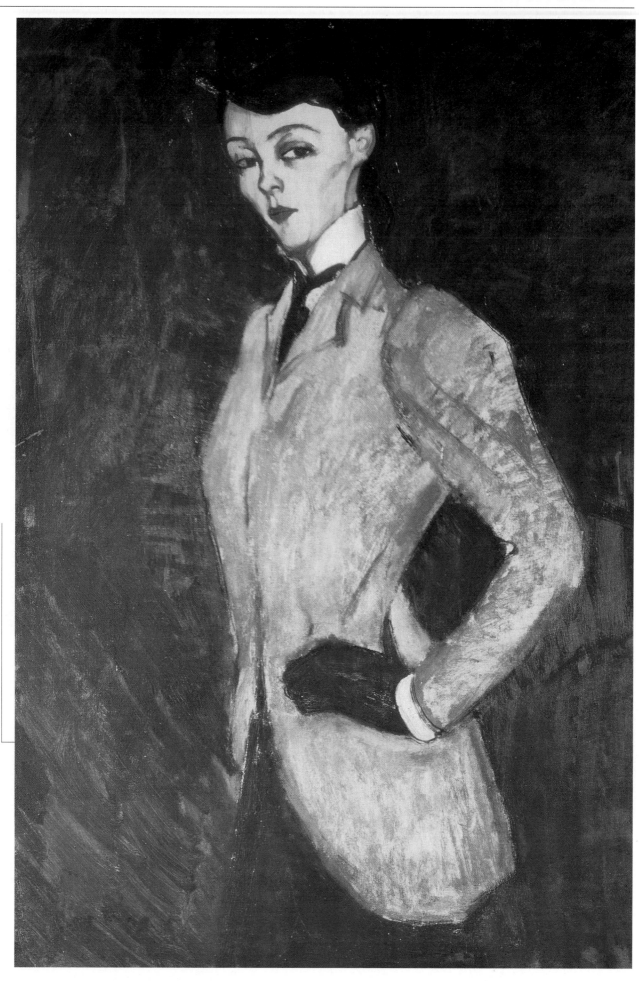

A MODERN MELANCHOLY

After a three-year pause, during which he devoted himself to sculpture, in 1914 Modigliani took up his brushes again and seemed reborn, as he had finally found his own style of expression. Abandoning his dark tones and sketchy outlines, trained by sculpture to abstract only the essential traits from each figure, the artist now began the brief but intense golden age of his art.

● During a period when the avant-gardes were overturning all the traditional painting genres, Modigliani went against the current and recovered the portrait as a privileged form of expression. Buoyed by the example of Cézanne, he portrayed self-contained forms, which all shared the same melancholy gaze.

● His style was by this point linear and sinuous. His palette lightened, even if earth tones prevailed, while the pigment became thinner and the surface more polished. Echoing Mannerism, Modigliani painted stylized, disproportioned figures dominated by unnaturally elongated necks.

● The painter's portrait gallery divides into two veins, both with the same compositional scheme and close viewpoint; these are the anonymous faces taken from the crowd, and the painter's friends, with which he offered a cross-section of the Paris of the time as fresh as the daily newspaper.

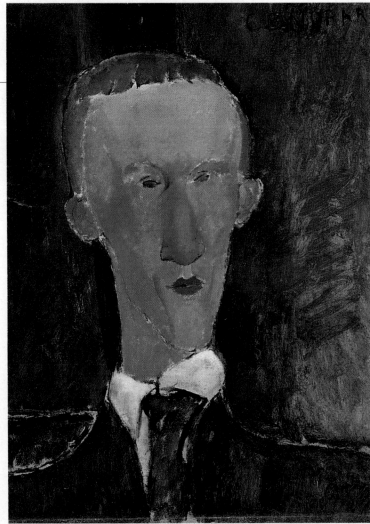

◆ BLAISE CENDRARS (1917, private collection). With his pronounced profile and gaunt face, the poet, a war veteran and missing a forearm, dominates the dark, sketchily painted surface.

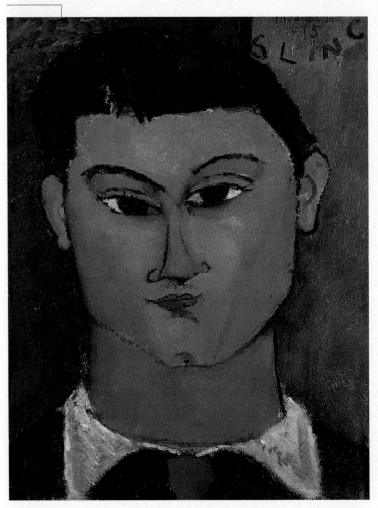

◆ MOISE KISLING (1915, Milan, Pinacoteca di Brera). The Polish painter Kisling (1891-1953), here portrayed with his stocky neck and massive shape accentuated by the earth colors, was one of the heirs to Modigliani's style.

◆ MADAME POMPADOUR (1915, Chicago, Art Institute). Modigliani portrays his eccentric companion of that time, Beatrice Hastings, dressed as the famous mistress of Louis XV, making a caricatural portrait, not only because of the outmoded hat but also her stylized facial features.

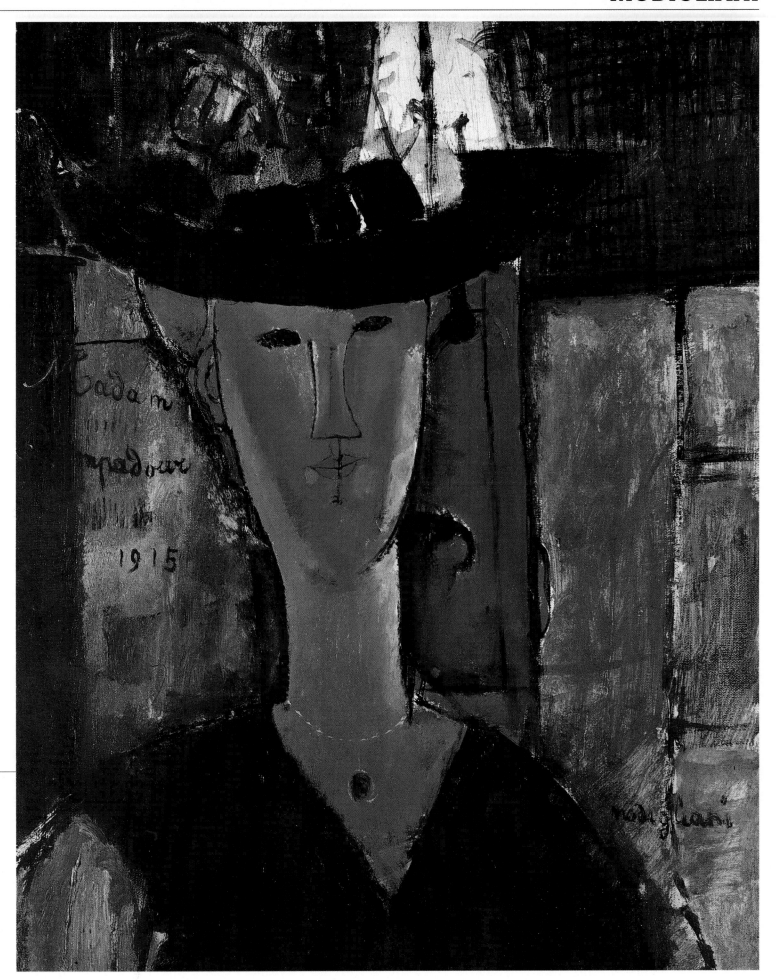

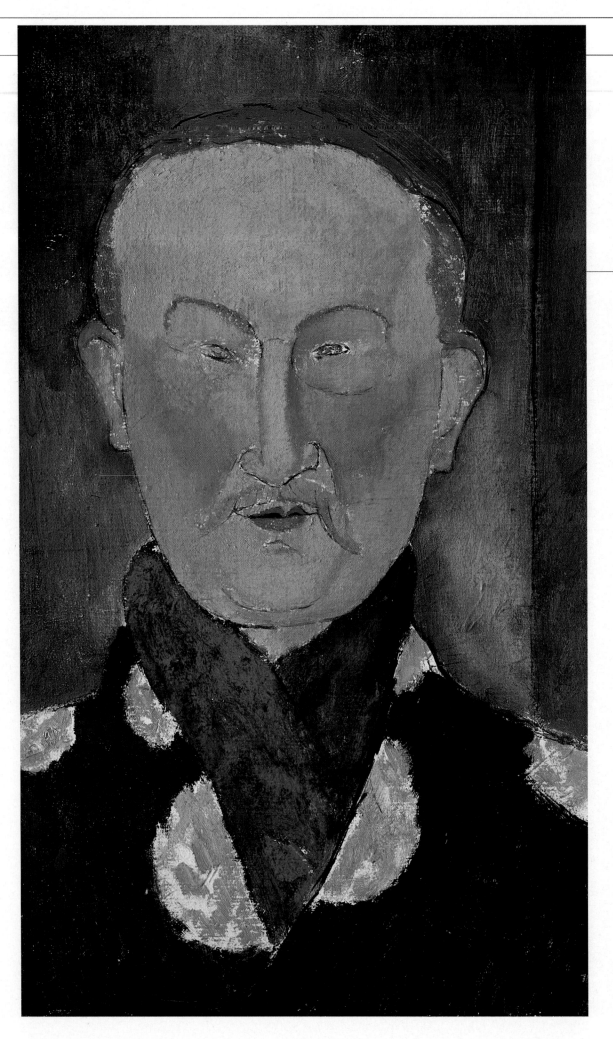

◆ LEON BAKST
(1917, Washington,
National Gallery
of Art).
The Russian costume
and set designer
who worked with
Diaghilev, famous
for the ballet *Après-midi
d'un faun*, is shown
from a very close
viewpoint, making
the man's face seem
severe, dominating
and filling the space,
and letting his self-
assurance shine
through.
The pronounced
stylization of
the features conceals
a subtle note
of caricature, while
the redness of the
cheeks is contrasted
by the intense electric
blue of the scarf,
injecting an energetic,
lively note into
the portrait.

◆ JEAN COCTEAU
(1916, Princeton
Art Museum).
In this portrait of
Cocteau (1889-1963),
Modigliani emphasizes
the artist's surly nature,
exaggerating
the verticality of
the figure with
the chiseled profile
of the face. Cocteau
sits as though on
a throne, blocked
in a hieratic pose,
absorbed in his own
thoughts, as revealed by
his eyes looking past
the viewer. According
to Cocteau, the faces
painted by Modigliani
were mute
conversations,
introspective portraits in
which, through
the melancholy
expression of the faces
and a sense of ill-being
intensified by
the sketchy brushwork
and pupil-less eyes,
the painter aimed at
capturing the intimate
nature of his characters,
their fears more than
their enthusiasms.

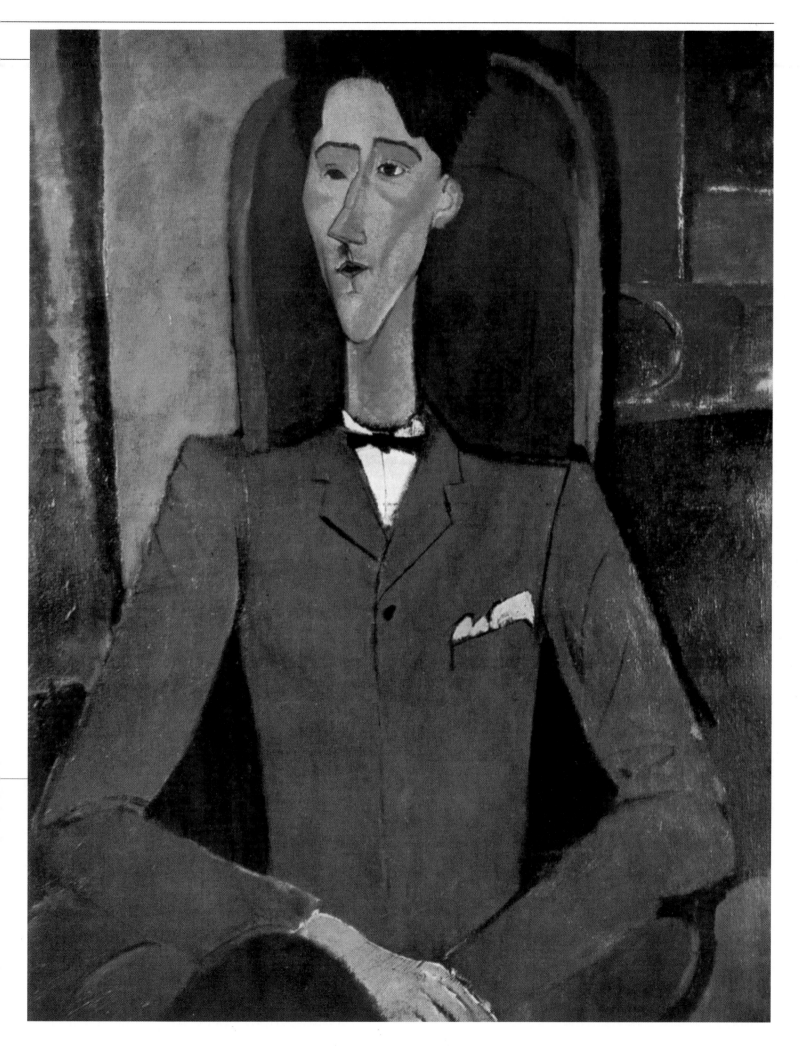

PRODUCTION: PORTRAITURE

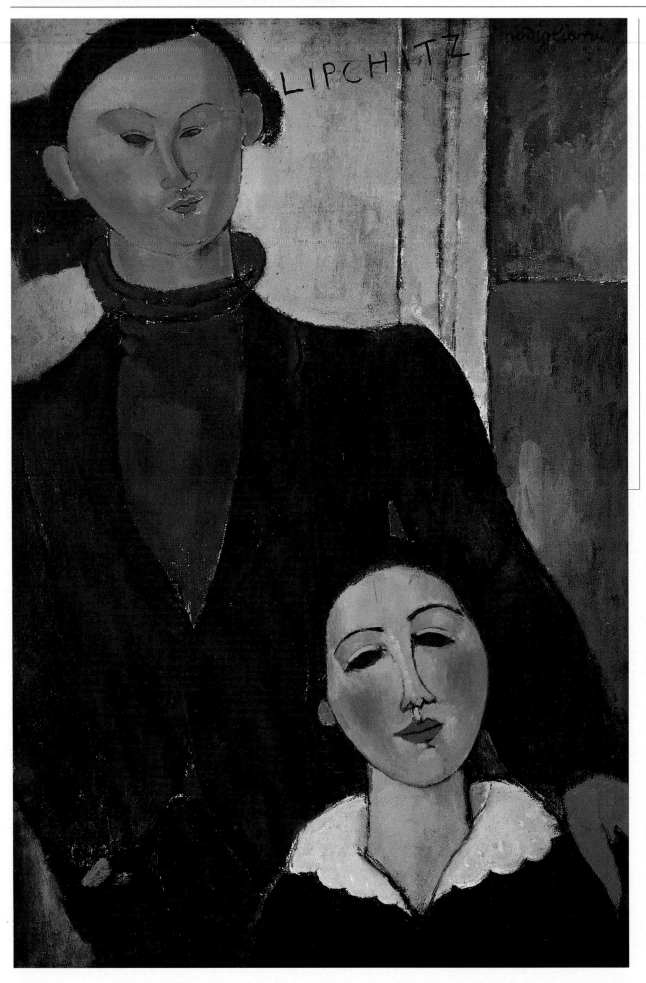

◆ JACQUES LIPCHITZ AND HIS WIFE (1916, Chicago, Art Institute). In this double portrait, painted in two weeks of intense labor, Modigliani depicts the Lithuanian sculptor (1891-1973) standing with his arm affectionately and protectively resting on the shoulder of his seated wife, Berthe. While the woman's face seems simplified to an extreme, to the point of seeming generic, in the almost caricatural features of the sculptor a greater individuality can be perceived, confirmed by the man's name inscribed at the top of the canvas. The chromatic contrast between the faces, illuminated by warm tones, the dark clothes, and the setting playing on cool colors, makes the figures stand out three-dimensionally. Lipchitz, who made a death mask of the painter and was his friend until the end, urging him to lead a healthier life, often recalled admiringly how Modigliani sculpted in stone "by instinct, as though guided by his deep love for the Italian Renaissance masters." The painter's habitual, repeated use of empty eye sockets, described as black, almond-shaped slits, inspired by primitive masks, deprives the portraits of any sort of vitality and places Lipchitz and his wife in a timeless dimension.

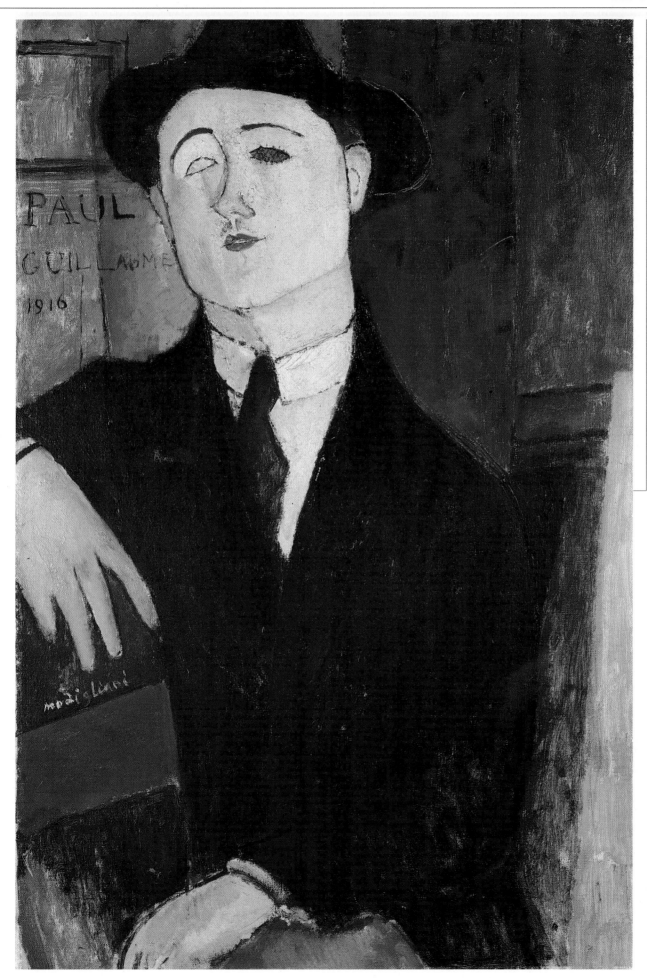

◆ PAUL GUILLAUME SITTING DOWN (1916, Milan, Galleria Civica d'Arte Moderna). The art critic and dealer Paul Guillaume – who met Modigliani through the poet Max Jacob – was the only buyer of Modigliani's works between 1914 and the beginning of 1917, as well as the one who supported the Italian artist, renting him a house and studio. This portrait was made in the studio which he rented to Modigliani, at no. 13 on the Rue Ravignan. The painter's lack of interest in the setting, which is rapidly sketched in with paint, is equalled by his skill in rendering the face, where the detail of the mustache and parted lips contrasts with the overall simplification of the features. In this painting, the viewer is struck by the sitter's bored expression, while his dandy-like air seems to contrast with the tribute of "*Novo pilota*" [new guide] which Modigliani assigned to him in the 1915 painting now in the Orangerie in Paris. A subtle vein of rancor on the artist's part toward his patron has been perceived here, due perhaps to Modigliani's conviction that Guillaume did not work hard enough in his favor. On the contrary, Guillaume often boasted that he had saved the artist from chronic indigence, and in an essay of 1920 remembers him as follows: "Even in his strange way of dressing like a bum, he had an indisputable elegance, a distinguished air which was amazing and sometimes frightening."

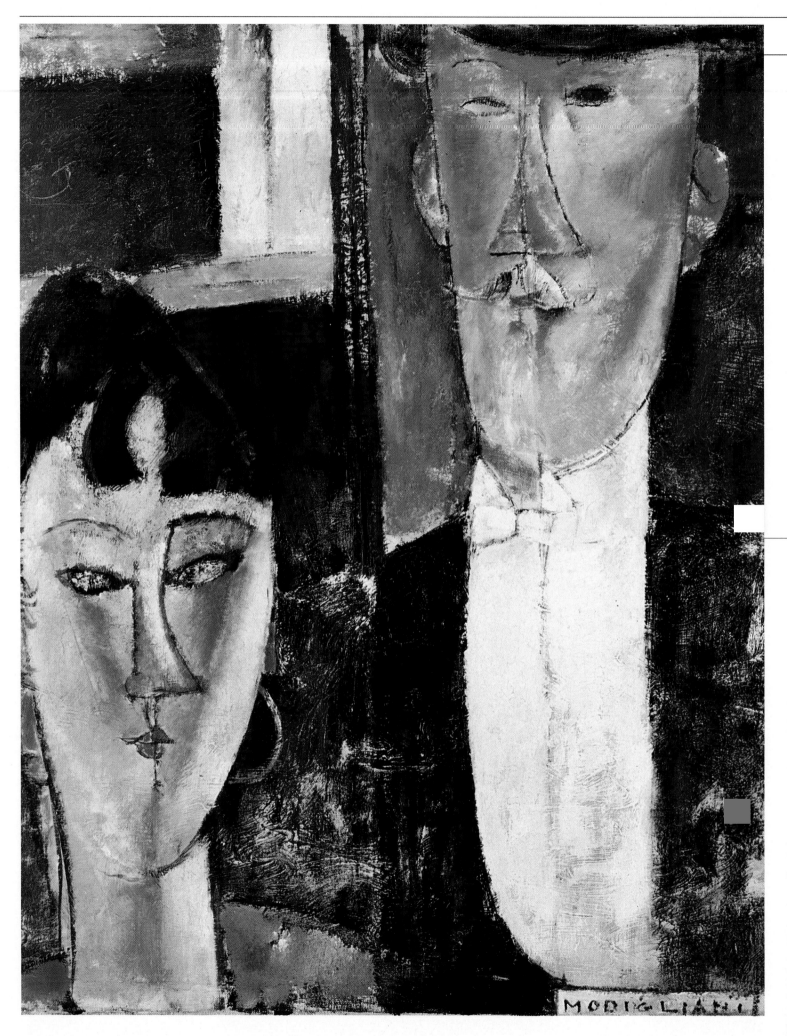

MODIGLIANI

22

♦ BRIDE AND GROOM (1915, New York, Museum of Modern Art). Along with the preceding portrait of Lipchitz and his wife, this canvas is a singular exception in Modigliani's *oeuvre*, as he prefers to paint isolated figures, whose inner intensity and often existential pain he can bring out. In the picture of the married couple, instead, a caricatural, ironic intent seems to prevail, intensified by the very close viewpoint, cutting off the two figures. Only the woman's head is depicted, which seems to be a transposition in paint of the artist's famous sculpted heads. The man fills the right side of the canvas with his massive chest, accentuated by his hat cut off by the upper edge of the picture. The two faces are constructed using right angles, but any static rigidity is attenuated by the curving profiles of the noses, which simulating depth of space on a two-dimensional surface introduce a brusque dynamic motion into the picture. In the play of intersecting lines can be seen an echo of Picasso's Cubist style, whose urge toward absoluteness and timelessness Modigliani picks up and reworks. No trace of a smile can be seen on their absorbed faces, almost contradicting their status as newlyweds.

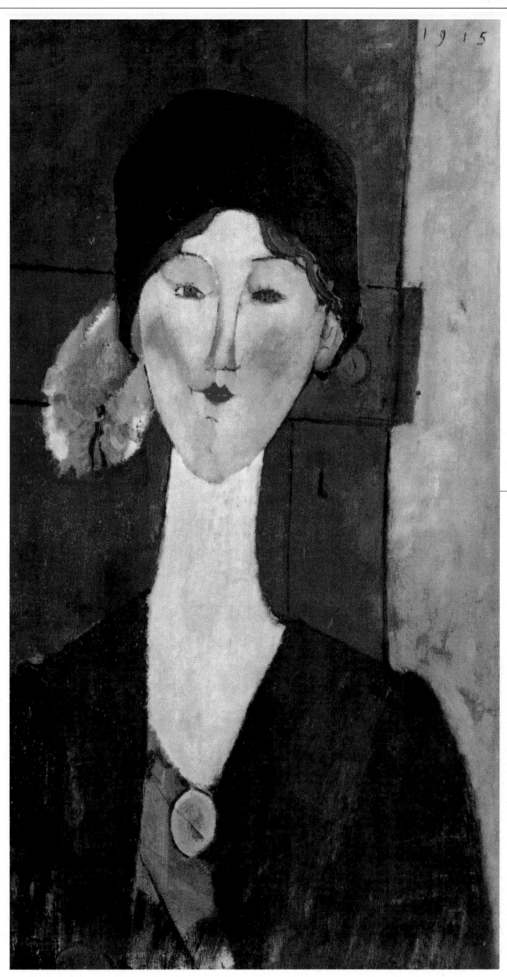

♦ BEATRICE HASTINGS (1915, private collection). The eccentric English poet Beatrice Hastings met Modigliani in 1914 and was his companion for the next two years. Their relationship was tempestuous and passionate, marked by stories about her aggressiveness and parties full of drugs, sex, and violence. In this strongly vertical canvas, Modigliani depicts Beatrice, who was born in South Africa in 1879 and committed suicide in England in 1943, with a flirtatious little hat that introduces into the scene a precise note of caricature pointed at her self-confidence and extravagance. Nonetheless, neither here nor in other paintings of his companion does Modigliani make any allusion to her arrogance and tendency to violence, to which he was often subjected. The artist, whom she called "a complicated character, a swine and a pearl," depicts Beatrice using a range of warm colors, which highlight her diaphanous skin and unnaturally elongated neck. The asymmetry of the feather in her hat and her dress, on which a medallion is hinted, is brought back into balance by the massive door in the background (or perhaps the door of a cupboard?) which contributes to rendering her strong, intransigent character.

OVERTURNING ACADEMISM

The year 1917 is a true watershed in Modigliani's production; leaving behind the numerous portraits of the preceding two years, he began one of the most refined series of paintings in modern art, his nudes. The size of his canvases suddenly grew larger to celebrate female beauty in all its fascination and mystery.

● The nudes were shown at the only one-man show organized during his life, in the turbulent exhibition at Berthe Weill's gallery in December 1917. The canvases in the window caused such a scandal that the police were forced to intervene.

● And yet, compared to his fellow artists, Modigliani stayed within the bounds of tradition and repeated in his compositions the poses of famous masterpieces like Botticelli's Venus, with which he aspired to an ideal, aristocratic, mysteriously pure beauty. Thus he repeated two compositional schemes: as in his portraits, he placed the models in a seated, hieratic position, or stretched them out on a bed, in barely hinted settings.

● In the languid faces of the women,

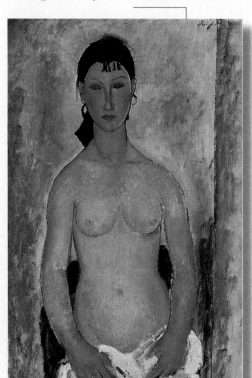

♦ STANDING NUDE – ELVIRA (1918, Bern, Kunstmuseum). The woman, with whom Modigliani had a brief affair, is described in an academic, immobile pose, while the cool colors of the background accentuate the figure's impression of timeless rigidity, almost a modern icon.

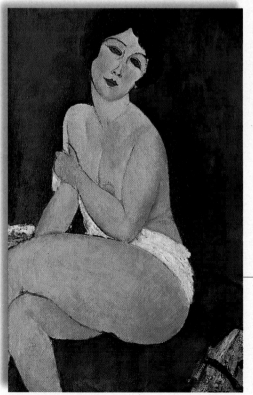

♦ NUDE SEATED ON A COUCH (1917, private collection). With a curious representation of Mannerist styles, Modigliani depicts the figure with a series of broken, ascending lines, balancing precariously in a pose that aims at conveying the naturalness of her gesture.

often with their eyes half-closed, a sort of complicitous intimacy with the artist has been perceived, which helped to spread the image of Modigliani the womanizer, a man who did not stop at just painting his models' portraits, an anecdotal aspect often repeated in books about him.

● In reality, his canvases show a curious cohabitation between an academic compositional structure and a fully modern vision (especially in the rare realistic insertions) which overturns every traditional scheme. The academic nude, placed in a closed setting, appeared by his time to be out-of-date, reworked not only by the Expressionists but also by Matisse and Picasso into an aggressive formula which immerses the figure in nature and transforms it into a network of lines of force.

● Modigliani, instead, used conventional layouts but, aiming at a coincidence of the occasional with the eternal, created modern Venuses which were at the same time hermetic and almost caricatural, artificial yet sensual, who unselfconsciously offer to the viewer their carnality yet are harnessed by elegant lines.

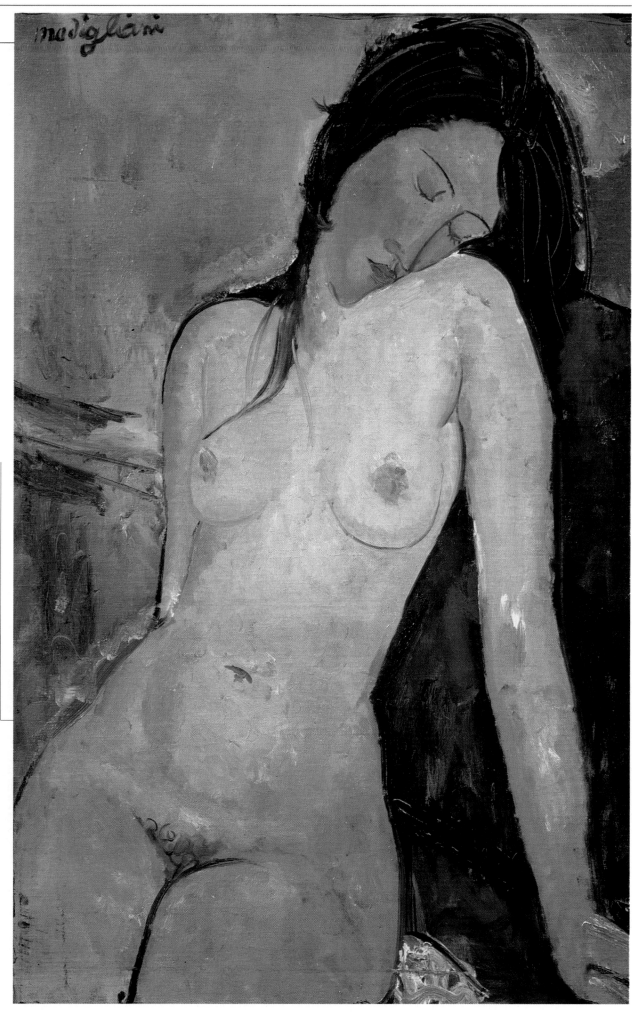

◆ YOUNG RED-HAIRED
WOMAN WEARING A
BLOUSE
(1918, private
collection).
The canvas repeats
almost mechanically
the pose of *The Birth
of Venus* by Sandro
Botticelli, with her
right hand on her
breast as though both
to cover and to display,
and her left hand
across her lap.
The Venus in
the Uffizi also
suggested the young
woman's unusual
smile and her tilted
head. Modigliani thus
reveals his aspiration
to the linear purity
and beauty
of the Renaissance.

◆ SEATED FEMALE
NUDE
(1916, London,
Courtauld Institute).
With a dynamic,
ascendent structure,
the nude cuts
the canvas diagonally
and stands out against
the shapeless
background.
The composition uses
the geometric form
of the triangle
as its common
denominator, repeating
it in the thin
profile of the face,
the space bounded
by the left arm,
the delicate angle
of the legs stretching
into the foremost
plane, and in
the pubic area.
A rapid, broken
line contours
the body and suggests
the woman's
sensual carnality,
heightened by
the viewer's
voyeuristic impression
of intruding
on a private moment,
as the model yields
to the tiredness
emanating from
the canvas.

PRODUCTION: NUDES

♦ LARGE NUDE (1917, New York, Museum of Modern Art). As is typical of Modigliani's reclining nudes, here too the woman is lying on her back and shows to the viewer the most intimate and delicate part of the female body, her pubes. The artist's dislike of buttocks is known; for this reason all his poses of female figures tend to exclude a rear view. In this sense a curious anecdote links Modigliani's name to Auguste Renoir (1841-1919). In 1918, Modigliani was spending some months on the Côte d'Azur, where he met Renoir through their mutual friend Anders Osterlind, the Impressionist's neighbor. The story goes that Renoir, at the height of his fame and wealth, gave Modigliani a great deal of advice, while the Italian artist was still unknown and poor. It seems that the master, who urged the young painter to caress his works, confided to him: "I feel the buttocks of my paintings for days at a time before considering them finished," a declaration to which Modigliani seems to have replied brusquely and irreverently, "Monsieur, I do not like buttocks." In this canvas, where the pubic area is not concealed by her hand, we are implicated as *voyeurs* in stealing an instant of the woman's intimacy as she sleeps, painted with a subdued range of colors and rapid brushstrokes.

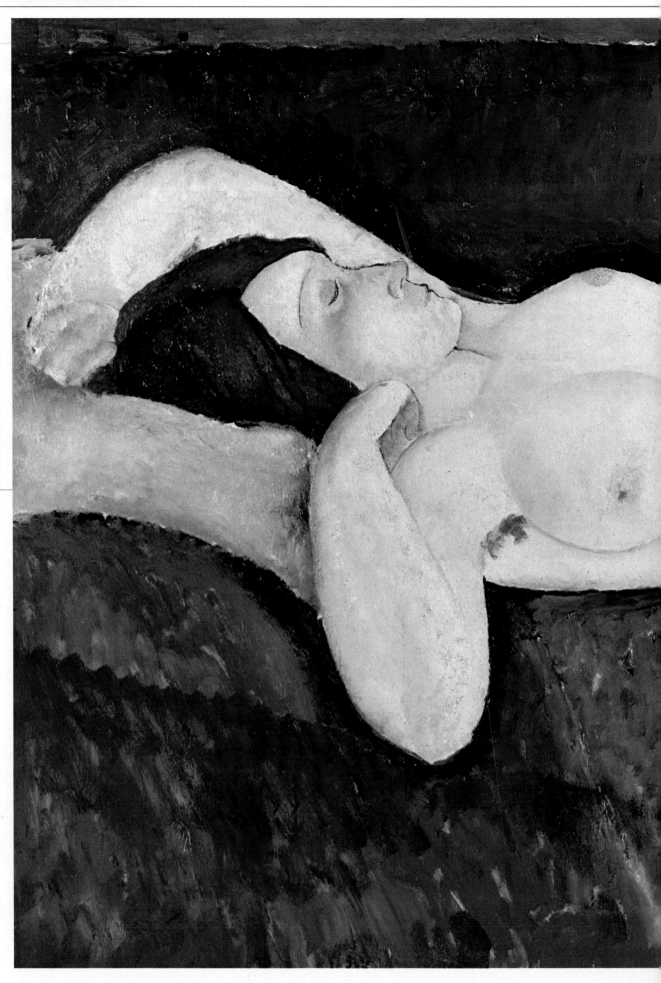

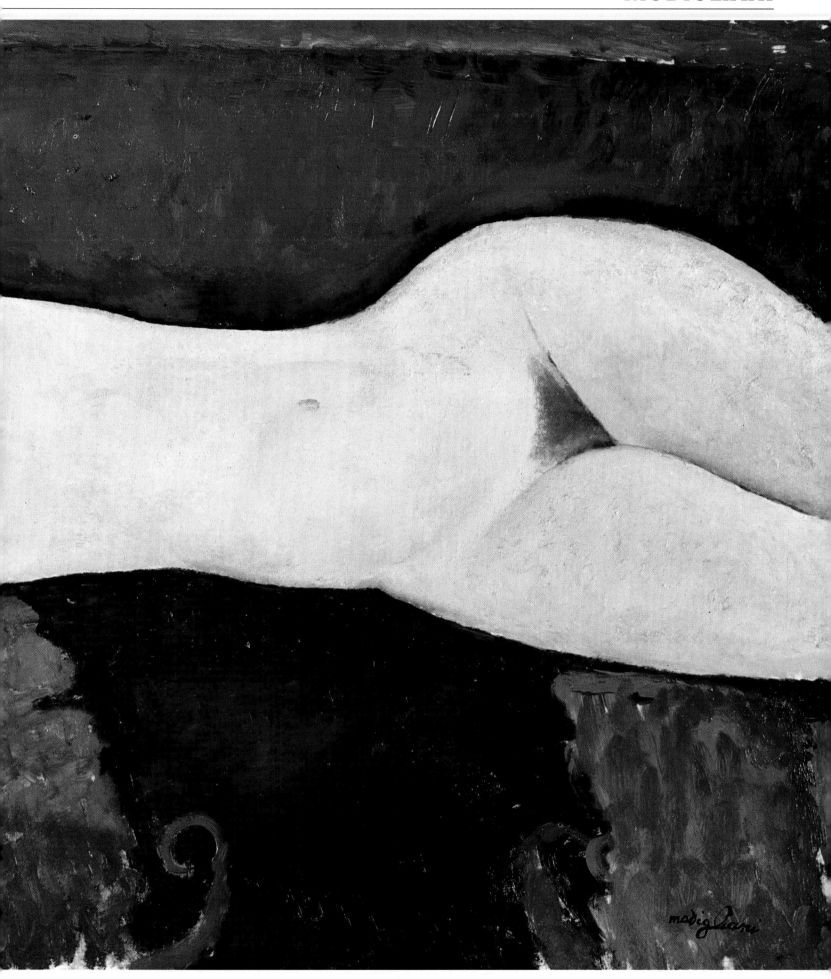

A LOST HUMANITY

In February 1917 Modigliani met Jeanne Hébuterne, at the time barely nineteen years old, who became his last faithful companion, silently sharing with the painter his poverty, suffering, and death. Her face appears in more than twenty-five portraits in which, despite the difference in pose, the feeling persists of the affectionate intimacy between the painter and model.

● In the first months of 1918, while the danger was growing of a German invasion of Paris, Modigliani's health worsened, and the artist, with the aid of Zborowski, moved with Jeanne to the Côte d'Azur. Despite numerous changes of residence and the young woman's discomfort due to her pregnancy and the birth of their child on November 29, their stay was enlivened

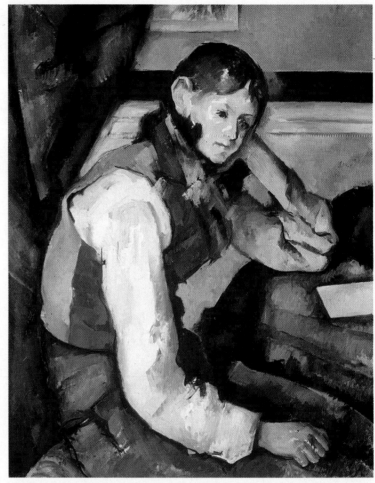

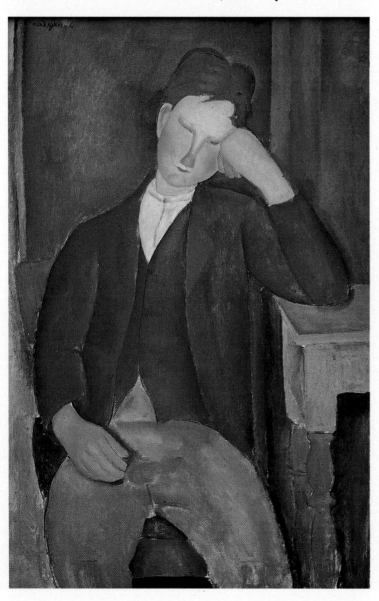

by the company of the painters Soutine and Tsugouhara Foujita (1886-1968), Hébuterne's ex-lover. Modigliani, who returned to Paris only in March 1919, experienced in the south an intense period of creativity, in which strong overtones of Cézanne can be detected. In the path of his predecessor, Modigliani painted simplified landscapes exuding the same air of expectation as his portraits.

● The most important part of the works done on the Côte d'Azur, however, was his portraits of ordinary people, children, peasants, housemaids. A simple, humble humanity appears on his canvas, where his traditional figurative scheme is strengthened by the powerful southern light.

● On his return to Paris his production slowed down, also because his health was declining. Sensing that the end was near, between relapses and recoveries in his last months the painter continued the series of portraits of Jeanne, and with the only self-portrait in his gallery took his sad leave from the world.

◆ PAUL CÉZANNE
Boy in a Red Waistcoat
(1888-90),
Zurich, Stiftung
Sammlung Bührle).
This famous painting
by Cézanne
(1839-1906), depicting
an Italian model,
expresses the same
human melancholy
which Modigliani
aims at emphasizing
in his works. With
an equally subdued
palette, just barely
enlived by
the waistcoat, Cézanne
shows the young boy
immobile and silent,
even almost solemn.

◆ LITTLE GIRL
WITH BRAIDS
(1918, Cambridge,
Ernest Kahn Collection).
The little girl's
frightened face, which
the photographic
framing pushes
aggressively into
the foreground, looks
out silently and arouses
in the viewer a surge
of tenderness and
something like
an intimate, protective
understanding. In this
face with her sad
expression, as though ill
at ease and certainly
defenseless, Modigliani
seems to meditate
on the fragility of life
and human destiny.

◆ PEASANT BOY
LEANING ON A TABLE
(1918, Paris,
Musées Nationaux).
The young peasant
sitting absorbed
in thought revives
Cézanne's
iconographical model,
made more symbolic
here by the frontality
of the composition.
With one hand inert in
his lap and the other
balled into a fist
holding up his head,
the young man recalls
traditional
representations
of melancholy.

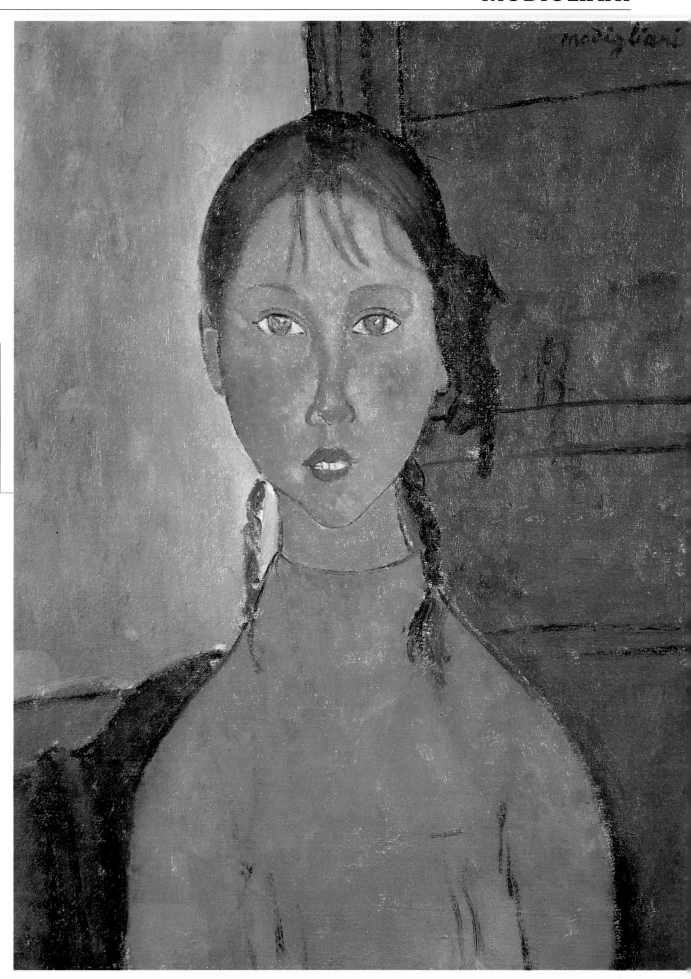

PRODUCTION: THE LAST WORKS

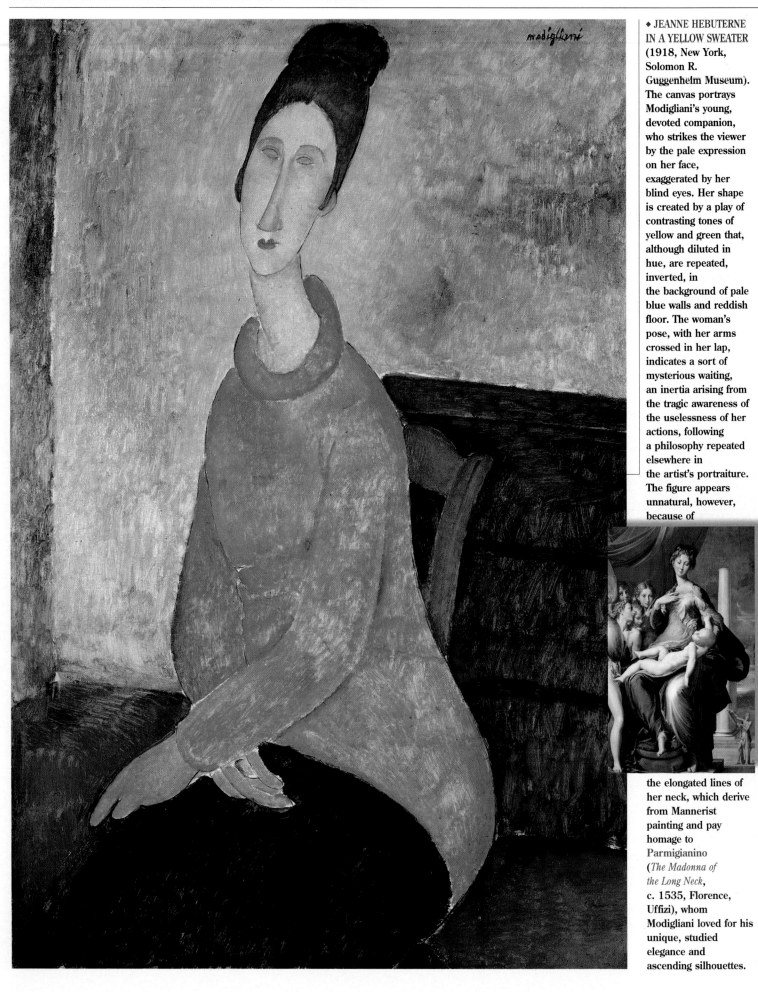

modigliani

◆ JEANNE HEBUTERNE
IN A YELLOW SWEATER
(1918, New York,
Solomon R.
Guggenheim Museum).
The canvas portrays
Modigliani's young,
devoted companion,
who strikes the viewer
by the pale expression
on her face,
exaggerated by her
blind eyes. Her shape
is created by a play of
contrasting tones of
yellow and green that,
although diluted in
hue, are repeated,
inverted, in
the background of pale
blue walls and reddish
floor. The woman's
pose, with her arms
crossed in her lap,
indicates a sort of
mysterious waiting,
an inertia arising from
the tragic awareness of
the uselessness of her
actions, following
a philosophy repeated
elsewhere in
the artist's portraiture.
The figure appears
unnatural, however,
because of
the elongated lines of
her neck, which derive
from Mannerist
painting and pay
homage to
Parmigianino
(*The Madonna of
the Long Neck*,
c. 1535, Florence,
Uffizi), whom
Modigliani loved for his
unique, studied
elegance and
ascending silhouettes.

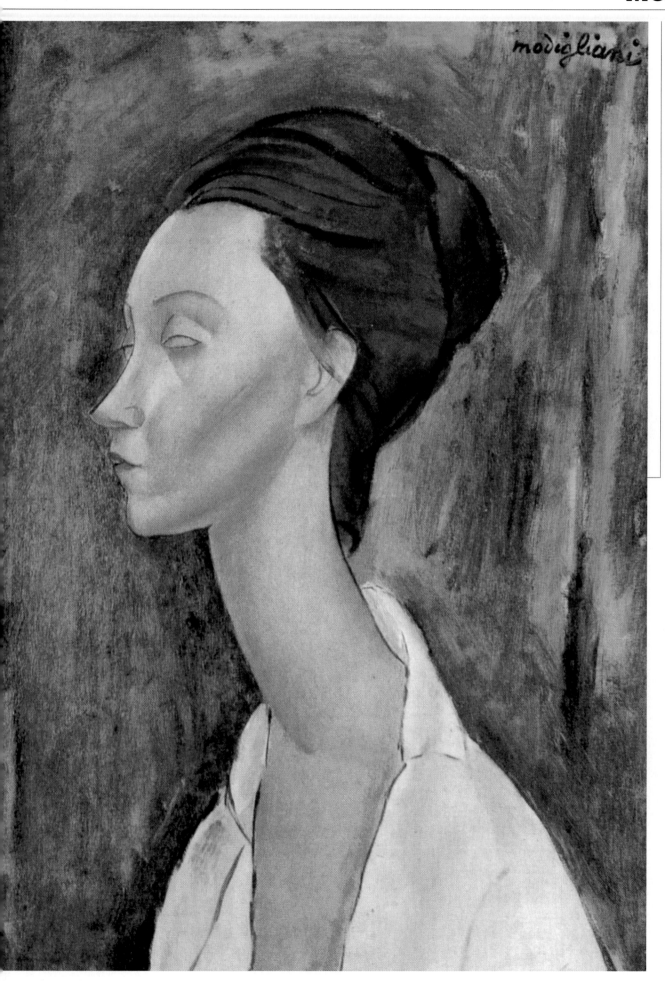

modigliani

◆ LUNIA CZECHOWSKA
IN PROFILE
(1919, private
collection).
Once again, thanks
to a bold compositional
concept using
a very close viewpoint,
Modigliani transforms
the face of
a young friend into
a modern idol,
made inexpressive
by the lack
of pupils, pursuing
the compromise
between physiognomic
fidelity and linear
abstraction
of his models'
features. The choice
to present the woman
in profile, in a position
which exalts her
improbable swanlike
neck, came
to Modigliani
from ancient medals,
but serves also
to reduce the visual
familiarity with
the observer
and give the woman's
face a timeless aura,
a sort of homage,
just as was done
by medals and coins.
Lunia, who
was a friend
of the Zborowskis
and lived with them
after her husband
was killed in war,
was painted fourteen
times by Modigliani,
in works of singular
expressiveness
which gave rise
to rumors
of an affair between
them. The canvas
does in fact
show an extremely
sensual depiction,
as revealed
by the emphasis
on the neck,
her plunging neckline,
and elegantly arranged
hair. Against
a monochromatic
range of cool tones
playing on variations
of blue, her thick
red hair, echoed
by bright red lips,
injects a note
of color.

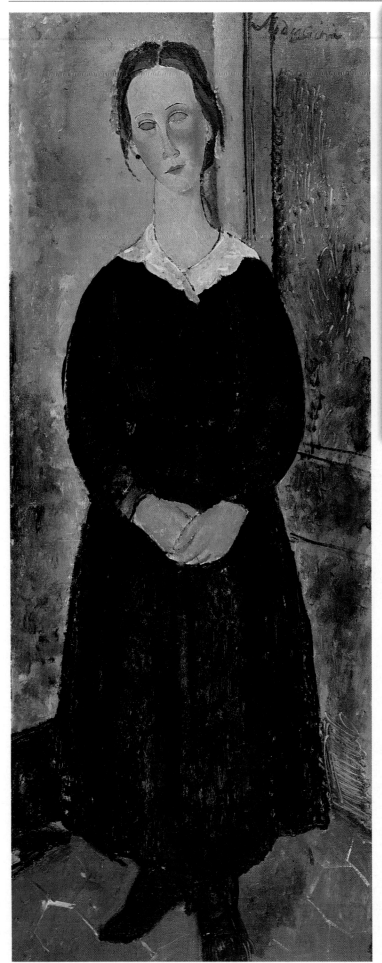

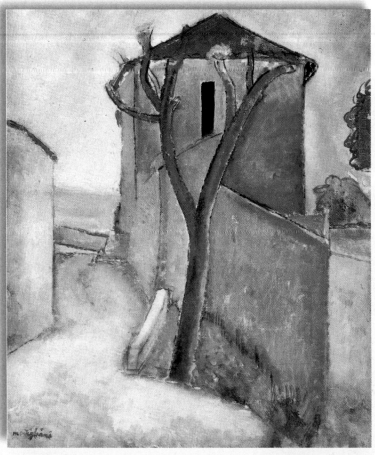

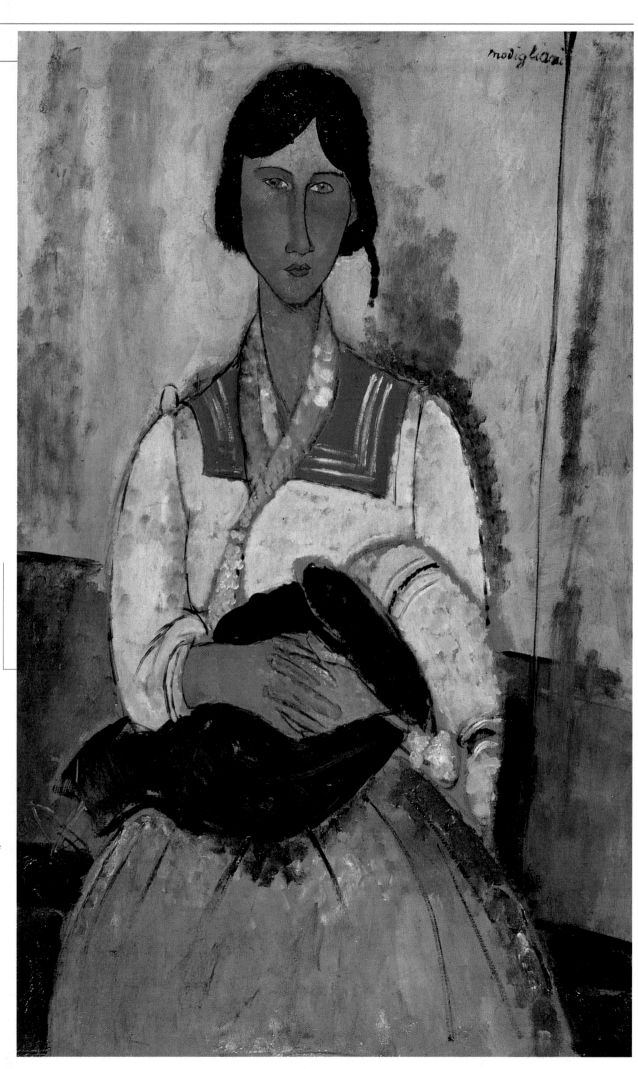

◆ YOUNG HOUSEMAID
(1918, Buffalo,
Albright-Knox Art
Gallery).
Of an undefined age,
somewhere between
a child and
an adolescent,
the housemaid
awkwardly dominates
the space.
Her inexpressive,
sad eyes and the
resigned pose of her
hands arouse a feeling
of human sympathy.

◆ TREE AND HOUSES
(1918-19, private
collection).
The canvas, one of
the four landscapes
painted on the Côte
d'Azur, represents
a desolate landscape,
onto which the absence
of light casts a sinister
note, intensified by
the skeletal tree
in the foreground.
The blunt outline of
the buildings draws
on the sculptural
compositions
by Cézanne.

◆ GYPSY WOMAN
WITH BABY
(1919, Washington,
National
Gallery of Art).
Like an image of
modern secular
motherhood, Modigliani
shows the intimate
embrace between
mother and child, even
if this gesture, accented
by the contrast of reds
and blues, expresses
worry above all.

◆ LANDSCAPE
(1919, Cologne,
Galerie Karsten Greve).
Even though
he maintained that "there
is nothing to express in
landscape," Modigliani
enacts a process
of elegant abstraction,
focused on the lines
of the tree trunks
and the grouping
of the buildings
in the background,
immersed
in a shapeless green.
The more brilliant palette
derives from Cézanne.

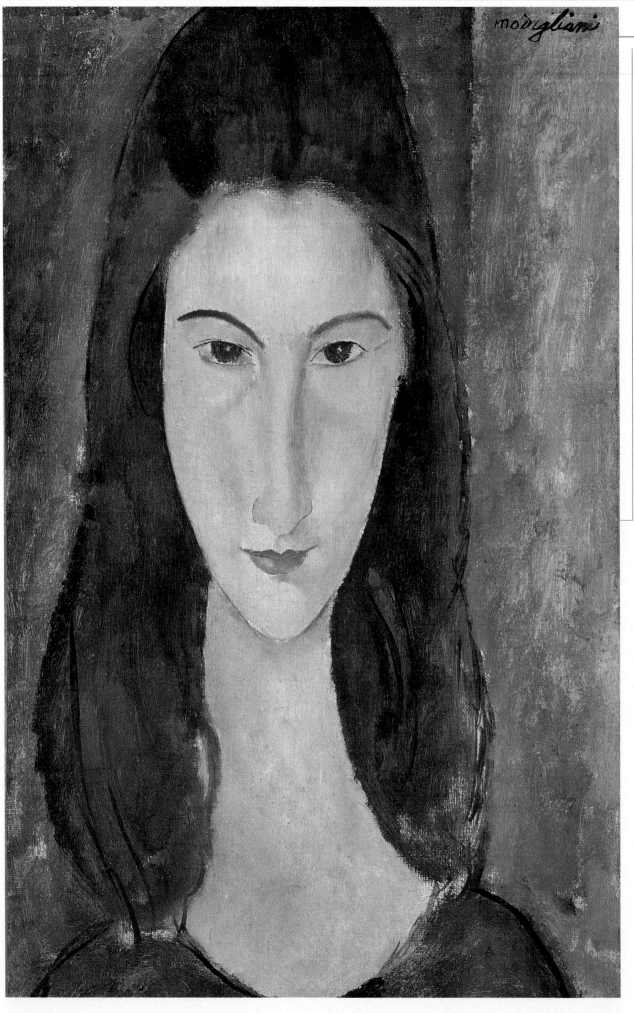

modigliani

♦ JEANNE HEBUTERNE (1918, Pasadena, Norton Simon Art Foundation). This portrait is one of the first of the young art student. Modigliani was fascinated by her slender features, which he exaggerates in the twenty or so portraits he made of her, and by her shy, sweet personality. He depicts her, in fact, with her head slightly down, as though indicating submission and reserve. Numerous stories tell how, after his turbulent affair with Beatrice Hastings, Modigliani found in Jeanne a companion ready to accept all his extravagance, a woman to order around even in public, devoid of any strength of reaction. Jeanne, who was a skilled draftsman and had been praised by various artists like the Futurist Severini, had had to fight her parents, who opposed her relationship with Modigliani to the point of alienating her from the family, a factor which undoubtedly contributed to her desperation when, the day after the artist's death, she found herself alone and pregnant, and decided to take her own life. Modigliani, who shows her here with her large almond-shaped eyes, emphasizes the sweetness of her look and her reserve, while the absence of a smile and impassiveness of her face render her ethereal and cancel out any complicity with the artist.

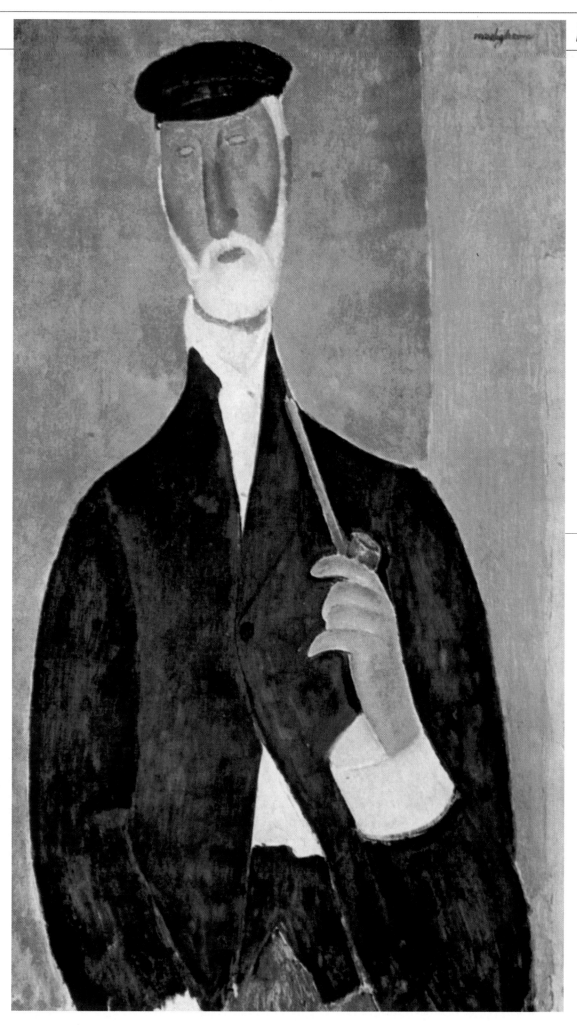

MODIGLIANI

♦ MAN WITH A PIPE (1919, Paris, private collection). Modigliani shows the man seated, serious and immobile, pipe in hand, intent on calmly passing the time. The old man, whose aspect recalls that of a sailor but who may be the notary of Nice, has a strongly elongated silhouette, similar to the outlines of Jeanne Héburtene and Lunia Czechowska, even if, compared to them, his massive chest indicates a decisive presence dominating the space. His nose is drawn on a diagonal like his pipe and the lapel of his jacket opening outwards; with these essentials Modigliani gives the scene a dynamic note and erases the allegoric nature of the figure, which would seem out of place. The palette is the artist's usual one, and the brushwork suggests the speed with which he painted this canvas, in some areas leaving it bare. Absorbed, his gaze lost in the distance, the man seems to have been captured during a long phase of inactivity, more than a moment of rest, which would have called forth a smile or at least an expression of satisfaction. Instead, Modigliani depicts him as though he has given up fighting and turned back in on himself, convinced of the tragic uselessness of his life. Such a figure arouses the viewer's sympathy and transcends the limits of the individual to become a general human condition.

AN ARCHAIC PURISM

Modigliani discovered his vocation for sculpture before his move to Paris. According to his biography, when he arrived in the French capital the artist introduced himself as a sculptor despite the fact that he had not yet sculpted anything, perhaps because of the technical difficulty this art involved.

● His first approach to sculpture dates to 1909, when Modigliani met the Rumanian sculptor Brancusi (1876-1957), who introduced him to the technique and revealed to him the arcane charm of essential forms. Attracted by the lesson of primitive art and the enclosed forms he discovered with Brancusi, and perhaps also because he felt his painting was stagnating, as it was substantially unnoticed, he tried his hand with the chisel.

● Like Brancusi, Modigliani considered as sculpture only work in stone, from sandstone to marble, shunning malleable materials like clay and plaster. Faithful to Michelangelo's (1475-1564) precept, he felt that sculpture must be done by *taking away*; he shared with the Florentine genius the conviction that form is already contained in matter and the sculptor must only help it to emerge, not create it according to his own pleasure.

● Thus he made his first twenty-five sculptures in stone (mainly sandstone) in the period between 1909 and 1914, during which he devoted himself to this new passion to the point of neglecting painting, returning to it only when his frail lungs made it impossible for him to continue to sculpt.

● The subjects belong to the tradition of primitive idols: they are abstract, impersonal faces, with an archetypal flavor, as seen already in the cerebral, purist sculpture of Brancusi and primitive masks, simplified practically to the point of abstraction.

● One series in particular stands out among all his production: the Caryatids, mythological figures used as architectural supports, which Modigliani translates into metaphors for mankind crushed by the weight of existence.

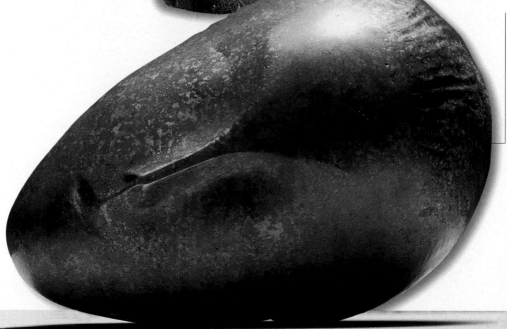

◆ HEAD (1910-11, private collection). With the generic title of *Head* and the practically identical aspect of the faces, except for the hairline and the exaggerated stylization of the nose, Modigliani creates a series of sculptures in sandstone or marble in which he represents female facial features with a few schematic lines and a lack of expression which recalls the synthetic language of primitive art.

◆ CONSTANTIN BRANCUSI *Sleeping Muse* (1909, New York, Solomon R. Guggenheim Museum). The sculptor, friend of Modigliani and his companion in poverty at the beginning, favored more elegant and softer forms of abstraction. In this bronze, a few barely hinted lines suggest the presence of the nose and lips, in a lyricism that contrasts with the arcane fascination of Modigliani's heads.

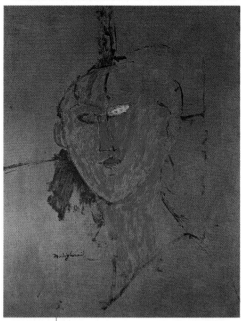

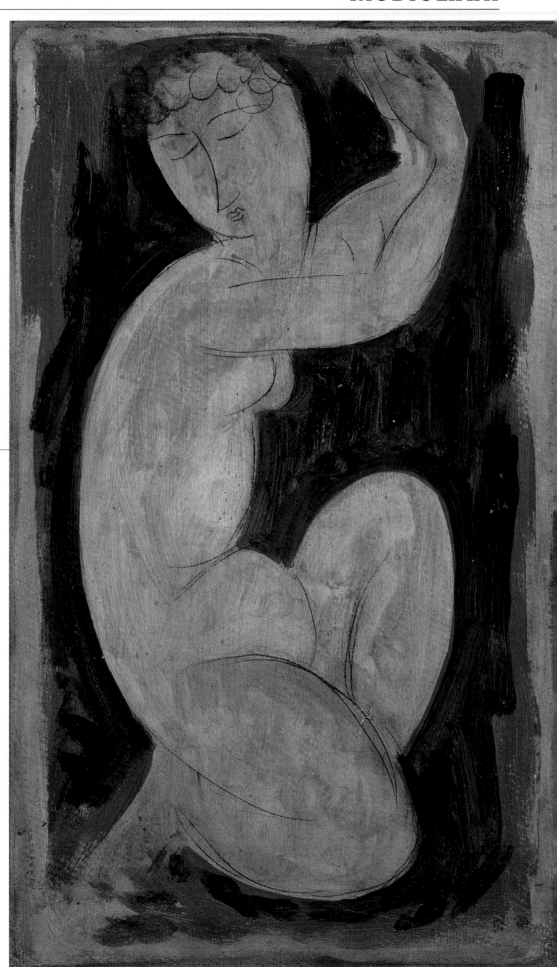

◆ RED HEAD
(c. 1915, Paris,
Musée National d'Art
Moderne).
Modigliani experiments
here with
a simplification
of the face using just
a few lines, enlivened
by the reddish color
of the skin. His intent
is not to capture
an expression but
the nature of the
human being as such.

◆ RED CARYATID
(1913, private
collection).
Modigliani shows
the figures holding up
an invisible burden,
with impassive faces,
as in the *Seated Caryatid*
(1911, private
collection, below).
With his Caryatids,
shown sometimes
frontally, others in
profile, he pays
homage to Greek art.

PRODUCTION: BEYOND PAINTING

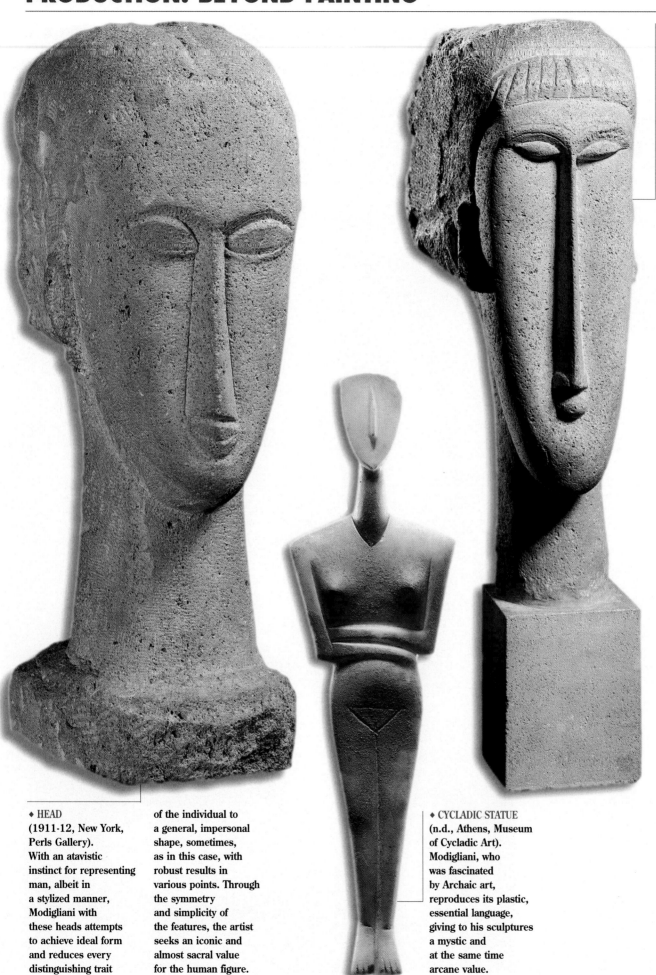

◆ HEAD
(1910-11, Washington, National Gallery of Art). Solemn and elegant in its minimalism, this head offers a contrast between the polished surface of the inexpressive face and the roughness of the unworked stone in the area of the hair. This reintroduction of primitivism, a fashion started by Gauguin and Picasso, constitutes once again an attempt to escape time, as was the case also with his works on canvas in a deliberately simplified style.

◆ CARYATID
(1913-14, Paris, Musée National d'Art Moderne). Compared to the other caryatids painted by Modigliani, this one is not standing but crouching and as though closed in on itself, in a softly modeled silhouette. The extreme tension of the limbs, which sustain an invisible weight, is described with sketchy strokes outlining the figure, whose original function in Greek architecture was to hold up the architrave. Modigliani loved this subject to the point of devoting to it some sixty drawings. Here the reddish color seems to inflame the figure.

◆ HEAD
(1911-12, New York, Perls Gallery). With an atavistic instinct for representing man, albeit in a stylized manner, Modigliani with these heads attempts to achieve ideal form and reduces every distinguishing trait of the individual to a general, impersonal shape, sometimes, as in this case, with robust results in various points. Through the symmetry and simplicity of the features, the artist seeks an iconic and almost sacral value for the human figure.

◆ CYCLADIC STATUE
(n.d., Athens, Museum of Cycladic Art). Modigliani, who was fascinated by Archaic art, reproduces its plastic, essential language, giving to his sculptures a mystic and at the same time arcane value.

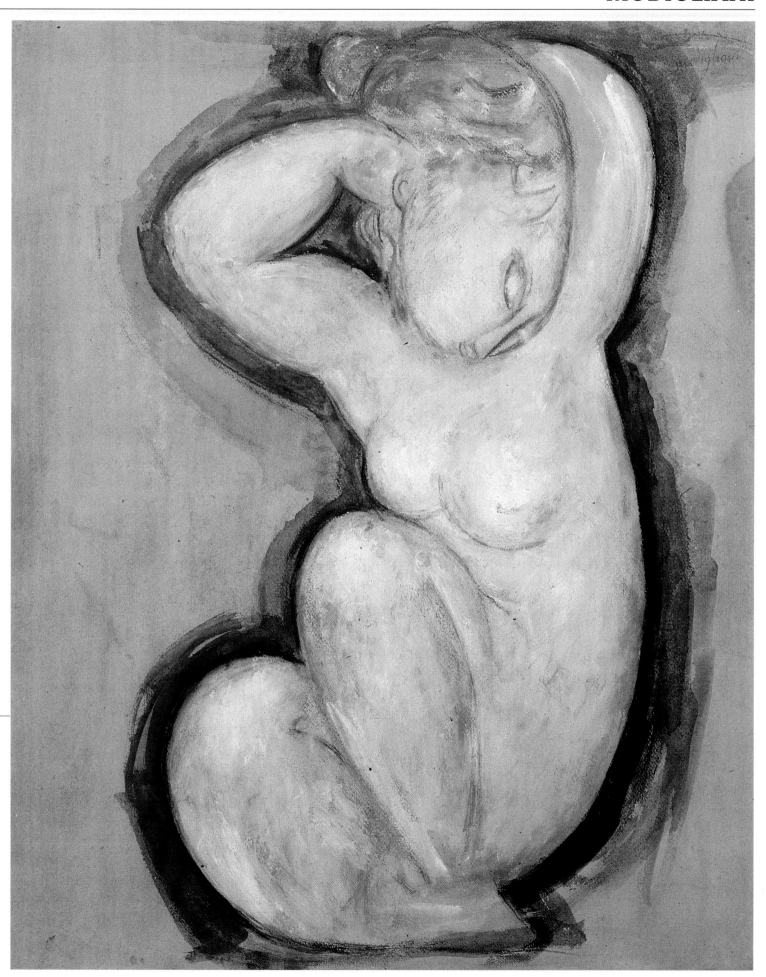

THE FORGE OF MONTMARTRE

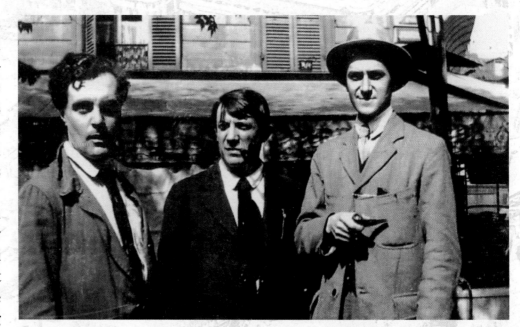

I n the year Amedeo Modigliani was born, 1884, in Paris the poet Paul Verlaine composed *Les Poètes maudits*, destined to become one of the artist's favorite readings. He took his first artistic steps in the sphere of the Macchiaioli, a trend strongly influenced by Impressionism, whose epicenter was Giovanni Fattori.

● But already during his sojourn in Venice in 1903, he discovered how provincial the work of the Macchiaioli was compared to the originals by Monet and other Impressionists, while in the dramatic intensity of Munch's painting and the sculpture of Auguste Rodin he saw the reflection of his own inner torment.

● Attracted by the air of innovation breathed in the French capital, Modigliani moved there. Here he met the future Expressionist Ludwig Meidner (1884-1966), who would call him "the last real Bohemian," and the sculptor Brancusi, who directed him toward sculpture in stone. At retrospective exhibitions, too, he found new models in Toulouse-Lautrec and Cézanne.

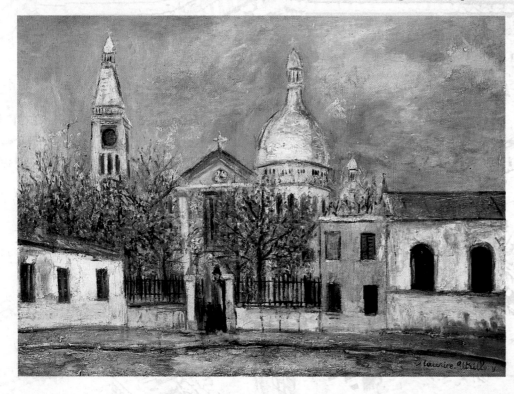

● On Montmarte, at the time the true forge of avant-garde art, unruly, aggressive movements were flourishing, starting with the *Fauves*, led by Matisse and André Derain (1880-1954), the Cubists Picasso, Juan Gris (1887-1927), and Jacques Lipchitz, whom Modigliani portrayed in quick sketches. Compared to their provocative art, epitomized by *Les Demoiselles d'Avignon* (1907), the Italian artist's contribution seems marginal. The painters in Picasso's circle and the poets gathered in the capital, from Jean Cocteau to Max Jacob (1876-1944), who all knew Modigliani, in reality had little to do with this curious personage, elegantly dressed in corduroy but with rude, quarrelsome ways.

● The poet Beatrice Hastings, the painter's lover, recalls how he hated them all, except Picasso and Jacob. The only friends to whom Modigliani was close were the painters Maurice Utrillo and Chaim Soutine (1893-1943), like him outsiders. The dark, desolate image of Montmartre fixed on canvas by Utrillo finds a counterpart in the intolerance of the faces portrayed by Modigliani and the dramatic torment of the figures painted by Soutine.

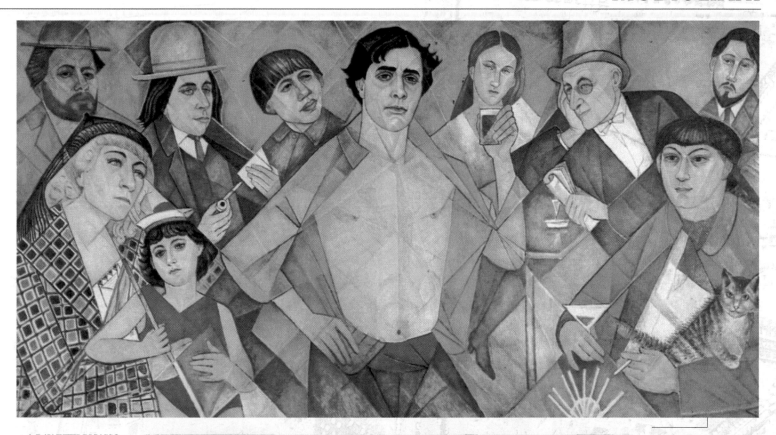

♦ A DAY WITH PICASSO
In the photo, taken by Jean Cocteau with another twenty all in the same day, Modigliani appears with Picasso, center, and the writer André Salmon, captured by the camera on an August Sunday in 1916 as they walked about the streets of Montmartre.

♦ MAURICE UTRILLO
Church of Saint Pierre (1916, Paris, Musée de l'Orangerie). Utrillo, son of the painter Suzanne Valadon, offers us a somber, desolate image of Montmartre due to the absence of people and the sinister light of a leaden sky about to rain. Figurative and immobile, the landscape conveys an overall air of melancholy.

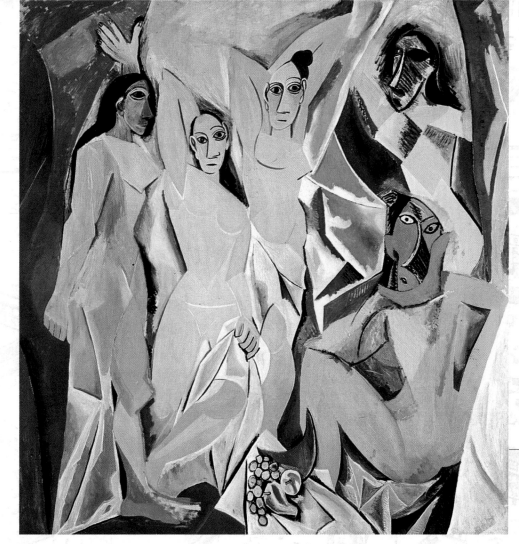

♦ MAREVNA VOROBIEFF ROSANOVITCH
Homage to Montparnasse Friends (1918, Geneva, Musée du Pétit Palais). With a style that recalls the Rayonnism of Larionov, the painting celebrates Modigliani in the center, with lifted glass and bare-breasted, suggesting his attractiveness compared to the clothed figures. Among his colleagues surrounding him, Foujita can be recognized with the cat. Modigliani lived only for a short time on Montparnasse, because he preferred Montmartre.

♦ PABLO PICASSO
Les Demoiselles d'Avignon (1907, New York, Museum of Modern Art). With the aggressive, fractured forms of this painting, Picasso revolutionized the concept of art and overturned traditional genres, which Modigliani, instead, reintroduced.

THE SCANDAL OF THE FAKES

Modigliani's style, going against the prevailing current, represented, as in a swan's song, the classical values of elegance and composure through those genres that just then, in the first two decades of the twentieth century, were being contested.

● And yet, he had an heir in Moïse Kisling, a Polish Jew who arrived in Paris in 1910 and immediately became Modigliani's friend, sharing with him a rebellious, impudent nature. It was Kisling who saved him from a common grave by buying him a place in Père Lachaise cemetery. Young and artistically

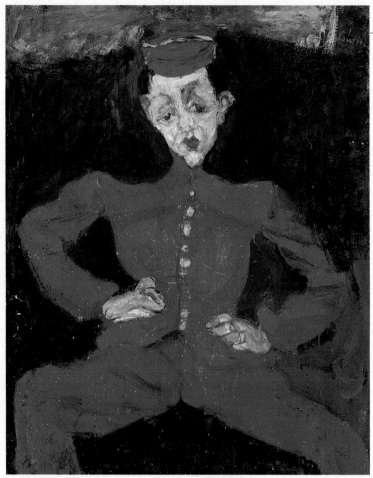

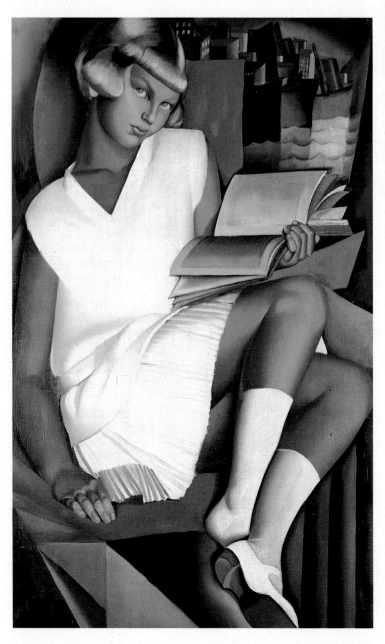

immature, Kisling was susceptible to the influence of Modigliani's art, which he assimilated in a softer style.

● Modigliani's sudden death, along with the legend which had grown up around him, led to a copious series of fakes, both in stone and on canvas. Thanks to the repetitiousness of his subjects, it was easy for fakers to augment the number of his works both by outright copies and by imitating his style in new works. An example of this was the scandal of the 1954 New York exhibition, where out of twenty-nine works, more than half turned out to be fakes.

● The most famous episode, however, occurred in July 1984, when two carved heads were fished out of the canal in Livorno, where, legend says, the artist threw them out of dissatisfaction before returning to Paris in 1909. The prank, the work of three boys, was only discovered two months later, after eminent scholars had attempted to pronounce on the presumed authenticity of the heads.

◆ CHAIM SOUTINE
Pageboy
(1927-28, Paris, Musée National d'Art Moderne). Using a clotted, rough pigment, Soutine created canvases whose style is almost Expressionist, in which he describes the difficulty of living and the melancholy of the figures, like this pageboy, giving no clue to his work.

◆ MOISE KISLING
Kiki of Montparnasse
(1925, Geneva, Musée du Petit Palais). Devoid of Modigliani's elegant, abstract composition, Kisling adopts a bright, shiny palette and detailed portrayal, which he opposes to the chromatic and expressive severity of the master. Here he portrays the model Kiki, whose real name was Alice Prin, one of the best known figures of the time, who had known Modigliani.

◆ TAMARA DE LEMPITZKA
Kizette en rose
(1926, Nantes, Musée des Beaux-Arts). In this canvas, the artist's linear style becomes hard and cold, while the girl's outline stands out from the narrow space of the picture; everything works together to draw out the arcane, eternal aspect of the forms, more than their real appearance. The brilliant colors and broken contour line push the young girl into a timeless dimension.

◆ TUSCAN LANDSCAPE (1898)
The canvas, now in the Museo Civico Fattori in Livorno, is both the first certain work by Modigliani and one of the rare examples of landscape painted by the artist. The leaden sky, brownish fields, and above all the desolation of this stretch of countryside, with no signs of life, recall the Macchiaioli style of Fattori, whom Modigliani emulated in his early work.

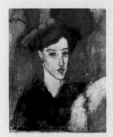

◆ HEAD OF A YOUNG WOMAN (1908)
The canvas, now in the Musée d'Art Moderne in Villeneuve d'Ascq, reveals Picasso's strong influence on Modigliani, who echoes here Picasso's *Head of a Woman* of 1901. Compared to the Spanish artist, however, the Italian maintains a sober palette which intensifies the dramatic nature of the portrait, where the marked grimace of the lips reveals a restless temperament.

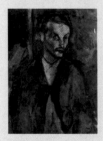

◆ THE JEWESS (1908)
The painting, shown in Paris at the *Salon des Indépendants*, is an example of Modigliani's approach to Expressionism. The unnatural brushstroke, based on strongly contrasting tones, gives the woman's face a pronounced ghostly look. Unlike what would later be his typical style, here the paint is roughly applied, at the expense of the line.

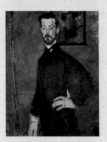

◆ BEGGAR IN LIVORNO (1909)
The canvas, representing a beggar in torn clothes and with a blurred, barely perceptible silhouette, was painted during a brief stay in Livorno and for this reason was given its current name. The pasty pigment and somber colors is Cézanne's typical palette which Modigliani discovered at the 1907 retrospective. The dramatized poverty of the subject is expressive of the painter's socialist spirit.

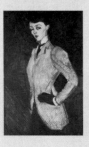

◆ PAUL ALEXANDRE ON A GREEN BACKGROUND (1909)
Elegant in his austere, detached pose, the young doctor, an art lover and protector of artists, including Modigliani himself, to whom he made a house available, stands out against the green ground, where the picture of the Jewess is hanging. His face is enlivened by reddish shadows, recalling the dense, constructive brushstroke of Cézanne. Modigliani met Alexandre in 1917 and a close friendship began.

◆ THE RIDER (1909)
The portrait of Baroness Marguerite de Hasse de Villers was Modigliani's first official commission, obtained through the intercession of his friend Paul Alexandre. The woman, who had posed in a red riding coat, which gave the picture its title, considered the artist's choice to change the jacket's color a personal affront and refused to pay for the portrait, subsequently bought by Paul Alexandre.

◆ FRANK BURTY HAVILAND (1914)
His early years in Paris forced Modigliani to reflect on the proposals made by French artists of his generation. In an experiment destined to go no further, in this painting now in the Los Angeles County Museum, he tried the pointillism technique, painting his friend, a lover of African art, using colored spots which make the canvas vibrate.

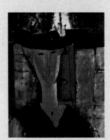

◆ MADAME POMPADOUR (1915)
In the portrait, now in the Chicago Art Institute, Modigliani's linear, plastic style can be recognized and is joined with an ironic note unusual in his production. His humor is seen not only in the outmoded hat worn by the model, the eccentric English poetess who was his lover at the time, but also in his comparison of her to Louis XV's mistress.

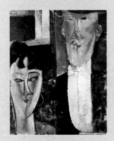

◆ BRIDE AND GROOM (1915)
Now in the Museum of Modern Art in New York, this is one of Modigliani's rare double portraits. The linear deformation of the features, deriving not only from the artist's recent experience of sculpture but also from Cubism, attempts to bring out the physicality of the faces but results in caricature. The rigid verticalism of the figures is softened only by the curve of the noses.

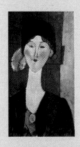

◆ BEATRICE HASTINGS (1915)
Modigliani presents Beatrice Hastings with a Manneristically elongated neck; he was involved with the English writer for two years, from 1914 to 1916, in a stormy affair. The verticalism of the work is accentuated by the shape of the door in the background and the sharp lines of the nose; everything works together to create an effect of rarefied simplicity and strength of character at the same time.

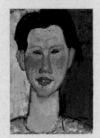

◆ CHAIM SOUTINE (1915)
In this picture now in the Staatsgalerie in Stuttgart, Modigliani portrays his Lithuanian friend Soutine, an Expressionist painter, suggesting the young man's rugged, jovial nature by the use of a rough pigment and highlighting his massive neck. According to his legend, Modigliani taught Soutine both the rudiments of social manners and of painting technique.

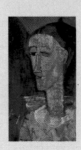

◆ PIERROT (1915)
The painting in Copenhagen, now in the Statens Museum for Kunst, clearly reflects the influence of Cubism on Modigliani's work, which borrows from Picasso and Gris the habit of inserting words into the picture and the choice of an almost monochromatic palette. Picasso also gave him his subject, who with his sad, defenseless humanity testifies to Modigliani's humanitarian socialism.

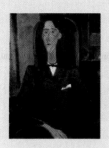

◆ JEAN COCTEAU (1916)
The painting, in the Princeton Art Museum, depicts the long, slender form of the artist, who became famous for his collaboration with Diaghilev's Russian ballet. As is typical of his portraiture, Modigliani abstracts his figures from reality and, ignoring all narrative detail, concentrates on the description of the figure, whose monumentality he accentuates with the vertical composition.

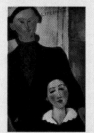

◆ JACQUES LIPCHITZ AND HIS WIFE (1916)
The painting, now in the Chicago Art Institute, portrays the Cubist sculptor with his young wife Berte. Here Modigliani reveals his skill in constructing a balanced image, carefully measuring the warm tones of the faces and the cool ones of their clothes and room to create an effect of depth in an otherwise flat composition. Despite the stylization, the double portrait was inspired by the couple's wedding picture.

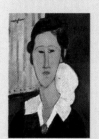

◆ ANNA ZBOROWSKA (1917)
The canvas, one of the few in Italy, in the Galleria Nazionale d'Arte Moderna in Rome, portrays with refined elegance the wife of the Polish poet and intellectual Leopold Zborowski, with whom Modigliani was close friends until his death. The couple, of whom the artist made numerous portraits both in oils and in charcoal, became Modigliani's new family.

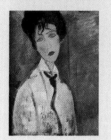

◆ WOMAN WITH BLACK TIE (1917)
The picture shows an unidentified female figure; striking here is the precious stylization of the face, with the usual empty eye sockets. In this sketchily painted canvas, in which only the head stands out, a sense of lightness is given by the serpentine line of her tie, hastily sketched, which suggests the firm, decisive nature of the young woman.

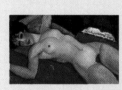

◆ RECLINING NUDE (1917)
The painting is one of Modigliani's most famous works, as it renews a traditional and by that point outmoded subject like the academic nude, inspired by the *Maya Desnuda* and melding a disquieting simplification of the features, like her dark closed eyes that recall the primitive masks discovered by the Cubists, with details of unexpected realism like her warm carnality or her underarm hair.

◆ NUDE SEATED ON A COUCH (1917)
The canvas repeats a favorite iconography of Modigliani in the period when he was concentrating on nudes. Differently from the more frequent reclining pose, here the woman is shown seated but in a pudic gesture, as she tries to hide her nudity, as though uncomfortable because the observer's gaze cannot be not distracted by any other element in the composition.

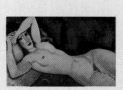

◆ RECLINING NUDE WITH LEFT ARM OVER HER FOREHEAD (1917)
The canvas, now in New York, repeats the setting and pose of the more famous *Reclining Nude* above, but the presence of open eyes provocatively looking at the viewer gives the image a greater realism while it reduces the suggestion of erotic charm, yielded mainly by the stylization of the forms.

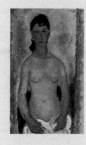

◆ STANDING NUDE – ELVIRA (1918)
The painting, now in the Kunstmuseum in Bern, is indicative of Modigliani's peculiar style, always elegantly balanced between geometric stylization and realism. While the monochrome wall is constructed using cool colors which push it back into the picture, the warm tones of the body bring the figure forward and lend it volume.

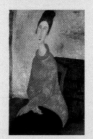

◆ JEANNE HEBUTERNE IN A YELLOW SWEATER (1918)
Justly famous, this painting in the Solomon Guggenheim Museum in New York portrays the artist's young companion in the customary pose for Modigliani portraits: her arms relaxed in her lap, her gaze rapt in thought, her shoulders bent forward. In the monochrome palette, a touch of vitality is given by the yellow sweater which infuses a warm note into the scene.

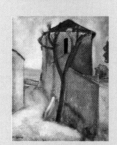

◆ TREE AND HOUSES (1918-19)
With the exception of a painting of 1898, Modigliani did not paint landscapes, a genre he seemed to shun. But when the first world war broke out and the danger of an invasion of Paris increased, he moved for a year to the Côte d'Azur, where this painting was made, under the strong influence of Cézanne, whose subdued palette and vigorously modeled forms are seen again here.

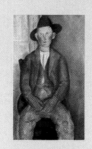

◆ THE LITTLE PEASANT (1918)
In the canvas in London, in the Tate Gallery, Modigliani pays homage to his master Cézanne, from whom he inherited the iconography of his portraits. The young peasant seated with inert hands, bent shoulders, empty eye sockets and gaze lost in space, is a modern icon of melancholy and resignation, yet the painter underlines his sad dignity.

◆ JEANNE HEBUTERNE SEATED IN PROFILE, IN A RED DRESS (1918)
The young woman was Modigliani's companion in the last years of his life, and the mother of the only child he recognized. She posed for numerous portraits, and is here depicted with a sweet expression which reveals Modigliani's affection, while the exaggerated verticalism of her long neck gives her a timeless air.

◆ GYPSY WOMAN WITH BABY (1919)
In this picture of modern secular motherhood, now in Washington in the National Gallery of Art, Modigliani reaches the heights of his art, as he unites a humanitarian spirit, directed toward the less privileged areas of society, with a refined, sober style, all playing on an almost monochromatic palette, barely revived by the young woman's red collar and its contrast with the blues.

◆ SELF-PORTRAIT (1919)
This is the only example of a self-portrait Modigliani made, when, in the last months of his life, his health was in serious decline, as suggested both by the thin face and the lost, sad expression in his eyes. In this sort of farewell to life, the painter shows himself with his palette in hand, in a composition balanced between cool and warm colors.

TO KNOW MORE

The following pages contain: some documents useful for understanding different aspects of Modigliani's life and work;
the fundamental stages in the life of the artist;
technical data and the location of the principal works found in this volume; an essential bibliography

DOCUMENTS AND TESTIMONIES

The Modigliani scandal

The writer Ken Follett gives in his novel The Modigliani Scandal *an image of the painter conforming to the legend of the Bohemian artist, who leads a dissolute, poverty-stricken life creating masterpieces in a state of semi-unconsciousness.*

"The old man glanced at a drawing hanging on the wall, a hasty sketch of a woman's head with an oval face and long thin nose. [...] Dee recognized the signature on the drawing. 'Modigliani?'
'Yes.' By now the old man's eyes were lost in the past. He seemed to be talking to himself. 'He always wore a brown corduroy jacket and felt hat. He said that art should be like hashish: it should show people the beauty of things, the beauty that you usually can't see. And then he drank, to see also the ugliness of things. But he preferred hash. Unfortunately, he had pangs of conscience. I think he had a strict upbringing. And then, he was delicate in health and worried about drugs. He worried but he took them anyway.'
The old man smiled and nodded as though finding some confirmation in his memories.
'He lived in the Impasse Falguière. He was very poor and had become skin and bones. I remember when he went to see the Egyptian section of the Louvre... when he came back he said it was the only section worth seeing!' He laughed happily. 'But he was a melancholy man,' he went on in a new tone. 'He always carried *Les Chants de Maldoror* in his pocket and could recite lots of French poems.'
Dee said in a low voice to jog the old man's memory without upsetting the chain of his thoughts:
'Did Dedo ever paint after he had smoked?'
The old man laughed. 'Oh, yes. When he was stoned he painted in a big rush, all the while shouting that this would be his masterpiece, his chef-d'oeuvre, and all Paris would see what

painting meant. He chose the brightest colors and threw them on the canvas. His friends would say that the painting was awful, and he would send them to the devil, replying that they were too ignorant to understand that this was twentieth century art. In the end, when he sobered up, he would recognize that they were right and throw the painting into a corner.'
The old man sucked in on his pipe, realized it was out, and reached for his matches. The spell was broken."

[K. Follett, *The Modigliani Scandal*, 1976
(from the Italian translation, Milan, 1986)]

The last Romantic

Corrado Augias reviews in his fictional biography of Modigliani the events and contradictions which marked the painter's personality, whom he called the last Romantic.

"Modigliani is the man who shuns even the temptation of compromise, preferring the damnation of poverty and illness to the money of what he considers giving in. When we say that he embodies a romantic ideal of the artist we are certainly referring to the tragic external circumstances of his life, to that dark shadow hanging over him from his adolescence on, to the energy that never faltered and the tenacity with which he sustained it. But this is only the superficial aspect of the question. Underlying it is the subtle ambivalence of his relationship with the world; he unrestrainedly took advantage of everything life promised and yet, in doing this, was engulfed by everything that life denies; he was pervaded by the obsessive sense of a goal that he himself probably knew to be unreachable and mixed this with the daily acknowledgment of his defeat. [...] For this too, and not only for his sensitive, reserved Jewish background, what he paints is full of melancholy, despite the sensuousness and beauty. Few artists have known as he did how to mix pleasure and pain, *joie de vivre* and a heartfelt perception of the pain of living, an even feverish sense of time that must be con-

sumed, joined with a constant awareness of the approaching end.
Modigliani breaks and in some ways tramples underfoot many middle-class moral conventions, but in the exercise of his art, which he made the purpose itself of his life, he shows a moral intransigence so rigid as to make any investigation of it an arduous task, also because this intransigence has very deep psychic reasons that make any rational attempt at explanation almost impossible."

[C. Augias, *Il viaggiatore alato. Vita breve e ribelle di Amedeo Modigliani*, Milan, 1998]

The magic of Egypt

In Paris, the Russian Anna Akhmatova was Modigliani's lover, while the poet Cocteau, despite their legendary conflicts, reveals through the intimate understanding of the artist's genius their spiritual affinity.

"During that time Modigliani dreamed of Egypt. He took me to the Louvre so that I could visit the Egyptian section; he said all the rest was not worth our attention. He drew my head wearing the coiffeur of an Egyptian queen or dancer, and seemed completely taken with the great art of Egypt. Evidently Egypt was his last passion. Then he became so independent, that looking at his canvases no memory comes to you of anything else."

[A. Akhmatova, *Modigliani's Roses*, Milan, 1982]

"It was not Modigliani who distorted and lengthened their elbows, it was not he who showed their asymmetry, took away an eye, lengthened their neck. All this happened in his heart. And like this he drew us at the tables of the Café de la Rotonde, like this he saw us, like this he loved us, he felt us, he contradicted us or fought with us. His drawing was a mute conversation, a dialogue between his line and ours."

[J. Cocteau, *Modigliani*, Paris, 1950]

HIS LIFE IN BRIEF

1884. On 12 July Amedeo Clemente Modigliani was born in Livorno into a cultivated Jewish family, the fourth and last child of Flaminio and Eugenia Modigliani.

1898. Contracted typhus and while ill had a premonitory dream which revealed to him his destiny as a painter. After recovering, he enrolled in the Accademia d'Arte in Livorno, where he studied under Guglielmo Micheli, a former student of the Macchiaiolo master Giovannni Fattori.

1900. Contracted tuberculoisis. Spent his convalescence between Capri, Naples, and Rome, and during his trip wrote five letters to his friend Oscar Ghiglia, which constitute a focal point among the few surviving documents by the painter.

1902. In Florence attended the Scuola Libera di Nudo, where Fattori taught. Visited and studied the Renaissance sites.

1903-06. In Venice with Oscar Ghiglia, enrolled in the Istituto di Belle Arti. At the 1903 and 1905 Biennali discovered French Impressionism, the sculpture of Rodin, and Symbolism, which awoke in him the burning desire to go to Paris, at the time the true forge of modern art.

1906. Finally in Paris, Modigliani lived on Montmartre and attended the Colarossi academy. Met Maurice Utrillo, his life-long friend, and the German future Expressionist Ludwig Meidner.

1907. Met Paul Alexandre, who became his first patron. Visited the restrospective of Paul Cézanne, who became one of his models, but his painting also felt the influence of Edvard Munch.

1909. Met the Rumanian sculptor Constantin Brancusi, who introduced him to sculpture production and technique.

1910. Met the German man of letters Max Jacob and the Russian poetess Anna Akhmatova, with whom he had an intense affair. Exhibited at the *Salon des Indépendants.*

1911. Exhibited his sculptures of the Caryatids, which he compared to "pillars of sweetness."

1912. Met the sculptors Jacques Lipchitz and Jacob Epstein. Exhibited some sculptures at the *Salon d'Automne.*

1914. Met the art dealer Paul Guillaume, who became his fervent supporter. At the outbreak of the first world war, he was excused from military duty because of his fragile health, which also forced him to stop his activity as a sculptor. Had a stormy affair, lasting until 1916, with the poetess Beatrice Hastings.

1915. Painted Picasso's portrait.

1916. Painted numerous portraits of friends and associated with Picasso, Max Jacob, Moïse Kisling. Met the Polish art merchant Léopold Zborowski, who became his friend and supporter. Met Simone Thirioux, with whom he had a son named Gérard, whom he never acknowledged as his.

1917. Painted a series of thirty female nudes (causing such a sensation at his first one-man show at Berthe Weill's gallery that some were withdrawn from the exhibition). In some faces can be recognized the features of Jeanne Hébuterne, Modigliani's new companion.

1918. Moved with Jeanne to Nice, where on November 29 his only legally recognized child, a daughter, was born, who was given her mother's name. During this period he painted his only four known landscapes.

1919. Some of his paintings shown in England. His art began to attract interest, but Modigliani became ill with tuberculosis.

1920. On January 24 Modigliani died in Paris, at the Charity hospital, of tubercular meningitis. The next day, Jeanne Hébuterne, nine months pregnant, committed suicide. Both were buried in the cemetery of Père Lachaise.

Marie Vassielieff, **New York, Perls Galleries.**

WHERE TO SEE MODIGLIANI

The following is a catalogue of the principal works by Modigliani conserved in public collections. The list of works follows the alphabetical order of the cities in which they are found. The data contain the following elements: title, dating, technique and support, size in centimeters, location.

BERN (SWITZERLAND)
Standing Nude – Elvira, 1918; oil on canvas, 92x60; Kunstmuseum.

CHICAGO (UNITED STATES)
Madame Pompadour, 1915; oil on canvas, 61x50.4; Art Institute.

Jacques Lipchitz, 1916; oil on canvas, 80.2x53.5; Art Institute.

COLOGNE (GERMANY)
Landscape, 1919; oil on canvas, 61x46.5; Galerie Karsten Greve.

DÜSSELDORF (GERMANY)
Max Jacob, 1916; oil on canvas, 73x60; Kunstsammlung Nordrhein Westfalen.

LONDON (GREAT BRITAIN)
Seated Female Nude, 1916; oil on canvas, 92.4x59.8; Courtauld Institute.

LOS ANGELES (UNITED STATES)
Jeanne Hébuterne, 1919; oil on canvas, 130x81; Sidney F. Brody Collection.

MILAN (ITALY)
Moïse Kisling, 1915; oil on canvas, 37x28; Pinacoteca di Brera.

Beatrice Hastings, 1915; oil on cardboard, 69x49; Fondazione Mazzotta.

Paul Guillaume Seated, 1916; oil on canvas, 80.5x54; Civico Museo d'Arte Contemporanea.

NEW YORK (UNITED STATES)
Head, 1911-13; limestone, 63.5x15.1x21; Solomon R. Guggenheim Museum.

Bride and Groom, 1915; oil on canvas, 55.2x46.3; Museum of Modern Art.

Nude with Necklace, 1917; oil on canvas, 73x116; Solomon R. Guggenheim Museum.

Boy in a Blue Jacket, 1918; oil on canvas, 92x63; Solomon R. Guggenheim Museum.

Jeanne Hébuterne in a Yellow Sweater, 1918; oil on canvas, 100x64.7; Solomon R. Guggenheim Museum.

PARIS (FRANCE)
Head, 1915; oil on cardboard, 54x42.5; Centre Georges Pompidou.

Paul Guillaume, 1915; oil on canvas, 105x75; Musée de l'Orangerie.

Lolotte, 1916; oil on canvas, 55x35.5; Centre Georges Pompidou.

Young Girl, 1918; oil on canvas, 92x60; Musée Picasso.

PRINCETON (UNITED STATES)
Jean Cocteau, 1916; oil on canvas, 100x81; Princeton University Art Museum.

ROME (ITALY)
Anna Zborowska, 1917; oil on canvas, 55x33; Galleria Nazionale d'Arte Moderna.

SÃO PAULO (BRAZIL)
Diego Rivera, 1914: oil on cardboard, 100x79; Museu de Arte.

Renée the Blonde, 1916; oil on canvas, 61x38; Museu de Arte.

Self-Portrait, 1919; oil on canvas, 100x64.5; Museu de Arte.

STUTTGART (GERMANY)
Chaim Soutine, 1915; oil on panel, 36x27.5; Staatsgalerie.

Reclining Nude, 1917; oil on canvas, 60x92; Staatsgalerie.

TOKYO (JAPAN)
Woman with Black Tie, 1917; oil on canvas, 65.4x50.5; Fujikawa Galleries.

WASHIGNTON (UNITED STATES)
Nude with a Blue Pillow, 1917; oil on canvas, 65.4x100.9; National Gallery of Art.

Leon Bakst, 1917; oil on canvas, 55x33; National Gallery of Art.

WEST PALM BEACH (UNITED STATES)
Daring (Pink Caryatid), c. 1914; gouache and chalk on paper, 60x45.5; Norton Museum of Art.

Caryatid, **New York, Perls Galleries.**

BIBLIOGRAPHY

For further study of Modigliani's artistic development, it is advisable to consult the general catalogues of his work.

Writings by Modigliani:

1930 A. Modigliani, *Cinque lettere giovanili al pittore Oscar Ghiglia,* in *L'Arte*

 A. Modigliani, *Lettere,* in *Belvedere,* May-June

Writings on Modigliani:

1926 A. Salmon, *Modigliani, sa vie et son oeuvre,* Paris

1930 G. Scheiwiller, *Omaggio a Modigliani (1884-1920),* Milan

1950 J. Cocteau, *Modigliani,* Paris

1953 J. Lipchitz, *Amedeo Modigliani,* London-New York

1958 J. Modigliani, *Modigliani senza leggenda,* Florence

1969 N. Ponente, *Modigliani,* Florence

1970 L. Piccioni-A. Ceroni, *Modigliani,* Milan

1984 J. Modigliani, *Modigliani racconta Modigliani,* Livorno

1988 G. Cortenova, *Modigliani,* in *Art Dossier* no. 30

1988-89 G. Cortenova-O. Patani (a cura di), *Modigliani a Montparnasse, 1909-1920,* Verona, Galleria d'arte moderna e contemporanea-Milan, Palazzo della Permanente

1989 A. Ceroni, *Amedeo Modigliani. Die Akte,* Stuttgart

1990 D. Marchesseau (ed.), *Modigliani,* Martigny, Fondation Pierre Granada

1991 W. Schmalenbach (ed.), *Amedeo Modigliani. Malerei, Skulpturen, Zeichnungen,* Düsseldorf, Kunstsammlung Nordrhein-Westfalen-Zurich, Kunsthaus

1992 O. Patani, *Amedeo Modigliani. Catalogo generale. Dipinti,* Milan.

1993 M. Fagiolo Dell'Arco (a cura di), *Modigliani dalla collezione del dottor Paul Alexandre,* Venice, Palazzo Grassi

1996 D. Krystof, *Amedeo Modigliani,* Cologne

 C. Parisot, *Amedeo Modigliani,* Paris

one hundred
paintings

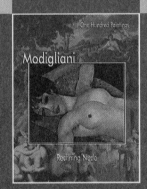